POULTON-LE-FYLDE

THROUGH TIME
Christine Storey

Christine Storey

AMBERLEY PUBLISHING

Acknowledgements

The author would like to thank all those who have provided photographs and information, particularly Poulton-le-Fylde Historical & Civic Society; Blackpool Central Library, for the photograph of St Chad's old clock from the Audrey Fuller Collection; Michael Allen; Georgina Benson; the *Blackpool Gazette;* the Brimelow family; William Hart; William Lawrenson; Cynthia Lee; Mr & Mrs Barry Robinson; Marjorie Rose; Norman Short; Richard Watt and Lynda Wright.

First published 2012

Amberley Publishing
The Hill, Stroud
Gloucestershire, GL5 4EP

www.amberley-books.com

ISBN 978 1 4456 0924 9

British Library Cataloguing in Publication Data. A catalogue record for this book is available from the British Library.

Typeset in 9.5pt on 12pt Celeste. Typesetting by Amberley Publishing. Printed in the UK.

Introduction

Situated only a few miles from the Irish Sea coast and close to the River Wyre, Poulton stands on some of the rare, relatively high ground in the flat lands of the Fylde. Evidence of the earliest human activity in the area came to light in 1970 when an almost complete skeleton of an elk was discovered and dated to 12,000 years ago. Barbs found with the skeleton provide the earliest evidence yet found of people this far north at that time. In 2008, remains of a group of Iron Age roundhouses – one of only three such sites in Lancashire – were discovered.

Poulton – 'the community by the pool' – is recorded in the Domesday Survey of 1086. Of the sixty hamlets and small villages listed in Amounderness, only sixteen were inhabited, possibly evidence of the desolation caused by continuing warfare in the north of England at the time. The survey also states there were three churches, but does not name them. There is good evidence that St Chad's church in Poulton was one of the three. The ancient church was re-ordered and clad in ashlar stone in 1752, giving it the deceptive appearance of a typical rectangular 'Georgian preaching box'. The tower probably dates from the 1650s, and the apse was added to the east end in 1868.

The term 'le-Fylde' was added to Poulton in 1842 to prevent mail being delivered in error to Poulton-le-Sands, near present-day Morecambe.

Poulton's Market Place has a market cross, stocks, a whipping post and fish slabs – a most unusual group to be found in one place. Before Blackpool developed as a seaside resort, hoteliers and innkeepers came to Poulton to buy goods for their visitors. In 1887 the town added a lamp to the group of items in commemoration of Victoria's Golden Jubilee.

For centuries the harbours at Skippool and Wardleys – across the River Wyre in Hambleton – were very successful, exporting and importing goods from as far away as Russia, but the Industrial Revolution passed Poulton by, with nearby Kirkham developing cotton

mills. Small-scale flax preparation, sail- and rope-making were the only industries in Poulton. By the mid-nineteenth century the harbours at Skippool and Wardleys were virtually disused; both are now successful sailing centres.

Until modern times many of the inhabitants of Poulton lived at subsistence level. Their cottages, built of cobbles, housed both the family and their animals, and the population was regularly struck down by recurring epidemics and poor harvests. In contrast, during the seventeenth century, local landowners – the Rigbys, the Walmsleys and James Baines, a local benefactor – had splendid three-storey town houses in the Market Place.

In 1554, the right to appoint the clergy to St Chad's was acquired by the Fleetwood family of Rossall, a link which continued into the 1930s. Sir Alexander Rigby of Layton Hall, near Blackpool, built a town house in Poulton; its date stone shows 1693 and is now in the churchyard, close to the tower base. James Baines was a successful woollen merchant from the Goosnargh area with a house and shop in Poulton. When he died in 1717 he left money in trust to fund three free schools for poor boys, all of which still bear his name. Sir William Hodgson was the first chairman of Poulton Urban District Council, formed in 1900, a churchwarden of St Chad's church and governor of Baines' school. In 1932 the new secondary school, built on Moorland Road, was named after him. He lived in Bull Street opposite the site of the present library and in later life became chairman of Lancashire County Council.

Over the centuries Poulton served as a 'commercial centre' for the local area, which was largely surrounded by farms, and it provided regular markets for livestock until the 1960s. The late 1960s saw the demolition of parts of 'old' Poulton, often because property was in need of modernisation. Land was cleared for the Teanlowe shopping centre to be built and the tithe barn was demolished to make way for a car park. Poulton continues to develop with changing tastes and new initiatives, and over the coming years the buildings of the 1960s will themselves be replaced.

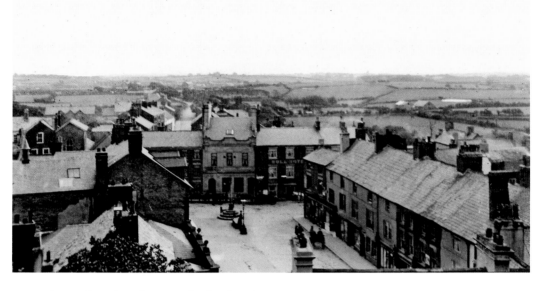

The Market Place from St Chad's Church Tower

Looking south over the Market Place in the 1920s. At the bottom of the picture the roof of the old building, backing onto the churchyard, can just be seen. The town centre is surrounded by farms and fields. In marked contrast, a photograph of a Victorian market held to celebrate Queen Elizabeth's Golden Jubilee in 1997 shows the town surrounded by unbroken housing development, much of which took place in the early 1960s.

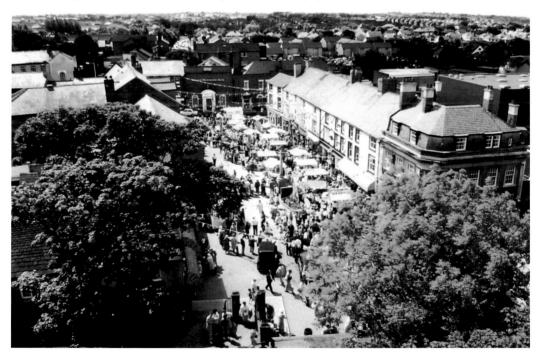

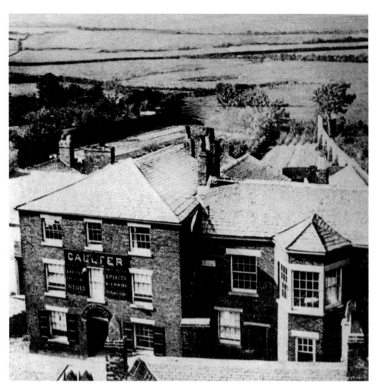

The Golden Ball from St Chad's Church Tower
The Golden Ball was originally a coaching inn catering for travellers between Lancaster, Preston and later, Blackpool. In its time it has held the police courtroom and served as a coffee room and newsroom, where the national and local newspapers could be read. Behind the inn were allotments. The modern view shows the site of the auction mart (now a car park), the railway line to Blackpool and properties in the Breck Road area, all developments of the 1890s.

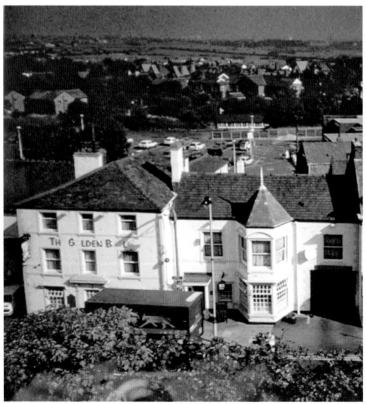

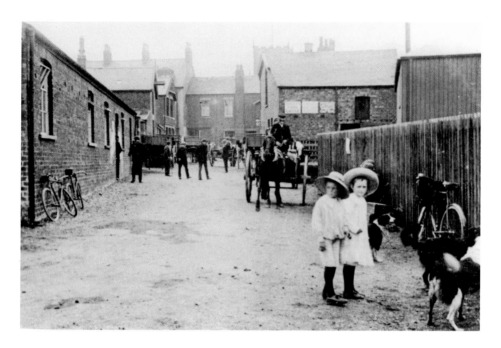

The Auction Mart

The Auction Mart was opened in 1897 behind the Golden Ball. The building on the left was the shippon, sited next to the bull ring and the calf ring, both of which were surrounded by railings and tiered seating. On the outside of these were the cattle pens. A slaughterhouse stood near the railway line and functioned until the early 1940s. The Auction Mart Company was dissolved in 1964. The modern view shows that the backs of the properties in Ball Street have changed little.

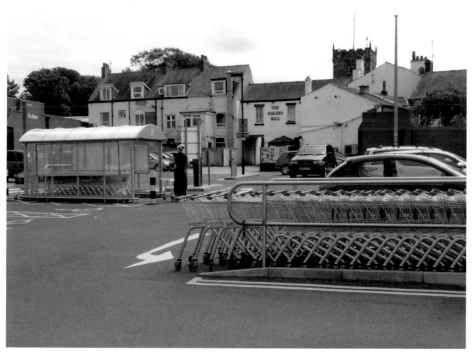

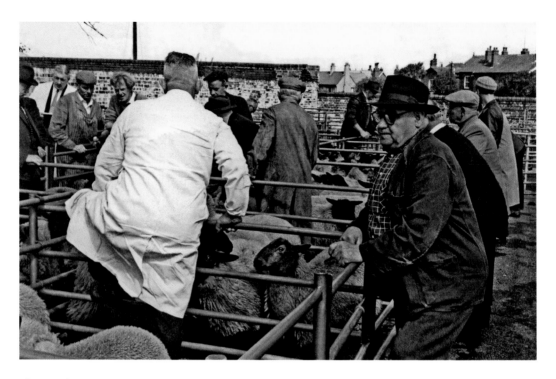

The Auction Mart in Action

A view from 1960. The man with trilby and glasses, Tommy Atkinson, was foreman of the mart for thirty-seven years, retiring in 1961. He began work in 1924 at 50 shillings (£2.50) a week, having got the job in competition with forty-two others. Livestock would arrive by rail at the goods station to be driven up the Breck to the mart. Some of the original brick wall survives alongside the railway line and rings for tethering bulls are still attached to another part of the wall.

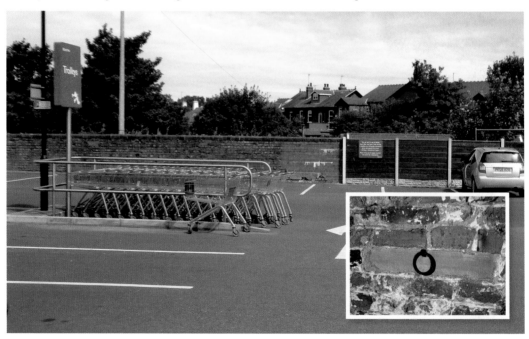

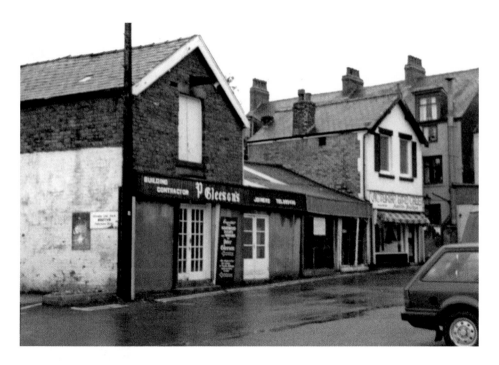

The Auction Mart Buildings

Built as the market office, part of the building was converted into a home for the stockman Thomas Atkinson and his family. By the 1970s this property had become shops – including Peter Gleeson's, The Victorian Birdcage, The Paper Tree and lastly 'Seekers Homeless in Blackpool' charity shop. It was demolished, along with the remaining mart buildings, in 2006.

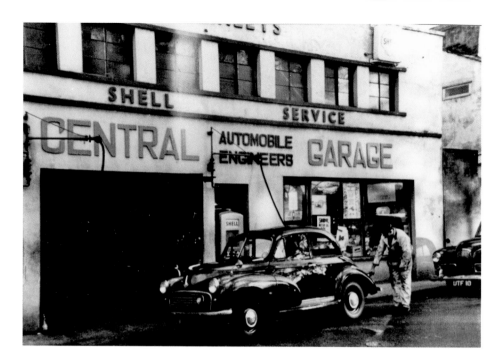

Charnley's Garage, Booth's Supermarket

Charnleys, an old Fylde family, had started a cycle business in the early 1900s. They established the Central Garage in Ball Street in the early 1920s and operated a vehicle hire service in Tithebarn Street. The firm moved to Cleveleys in the late 1960s and the property was then rebuilt as a branch of E. H. Booths. The supermarket incorporated several of the old Auction Mart buildings.

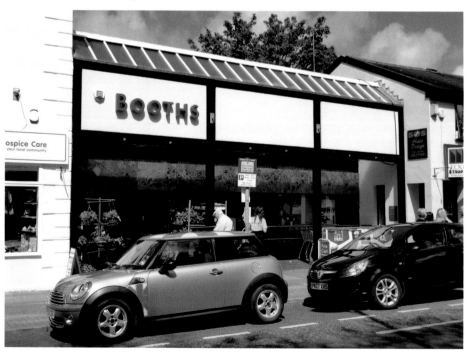

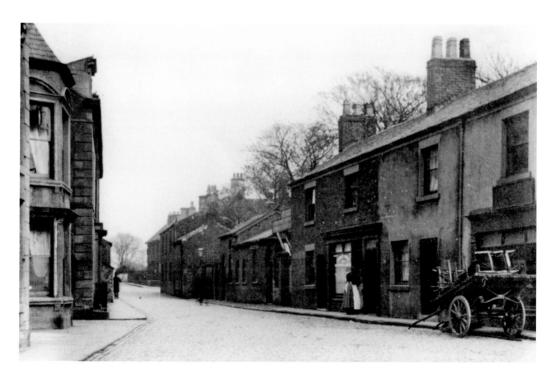

Ball Street

On the left is the Golden Ball. On the far right, hidden from view, is the Thatched House. A conglomeration of buildings had grown up next to the Thatched, backing onto St Chad's churchyard. The properties included a house and billiard hall, stables and a coach-house. Three shops completed the row. After much negotiation all these buildings were demolished in 1910. It is said that newspapers and coins were incorporated into the new stone wall, built in 1911.

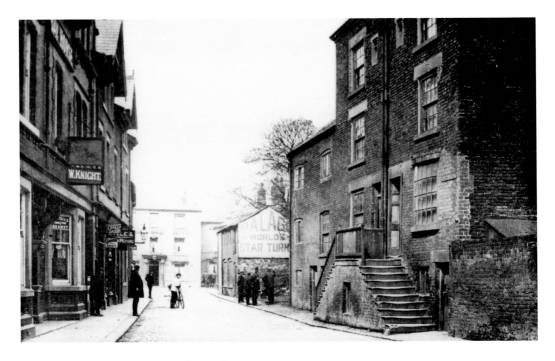

Twenty Steps and the Golden Ball

The property on the right backed onto the churchyard and included a lodging house where Irish workers stayed at harvest time; it was demolished in 1910. On the left are the original Bay Horse and the Plough pub, with a lamp on the wall. In the distance the Golden Ball was one of Poulton's main coaching inns, and housed the town's reading room. The Auction Mart was built behind it. Church Street was pedestrianised in 1983.

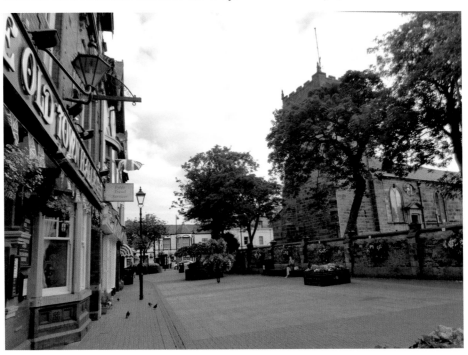

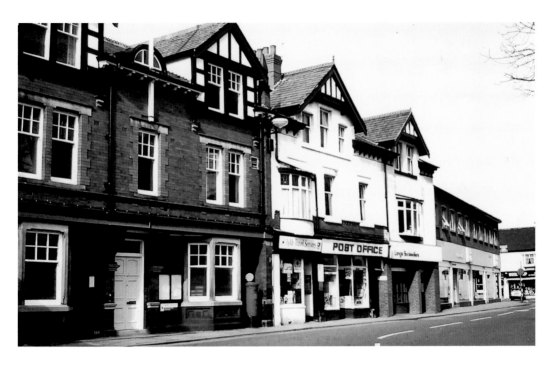

The Bay Horse and the Post Office

This property was rebuilt in 1910 and included the Bay Horse pub on the extreme left. Poulton Urban District Council was formed in 1900 and, after council meetings had been held in various venues, the Bay Horse was converted into Poulton's first town hall in the 1930s. So it remained until 1988, when the old town hall reverted to its original use and was renamed The Old Town Hall pub.

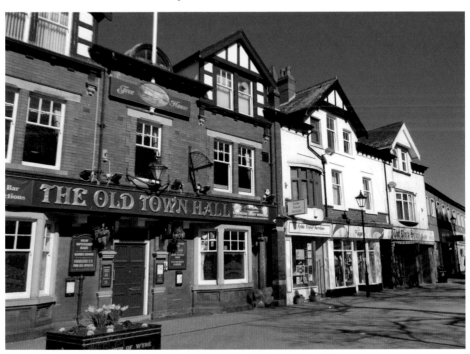

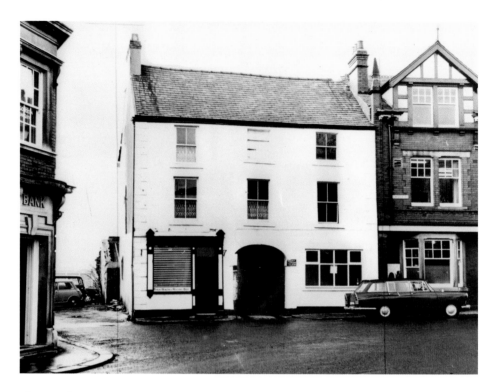

The Teanlowe Centre

The bank on the extreme left was once the King's Arms pub. The white building was a butcher's. It became the council's public health and housing department before being demolished in 1970. Burlington Avenue ran down the side and led to one of the town's three abattoirs. The building on the right was the town hall, now a pub. The Teanlowe shopping centre was named in 1973 by a pupil from Hodgson School, commemorating Teanlay Night, an ancient ritual held on All Hallows' Eve.

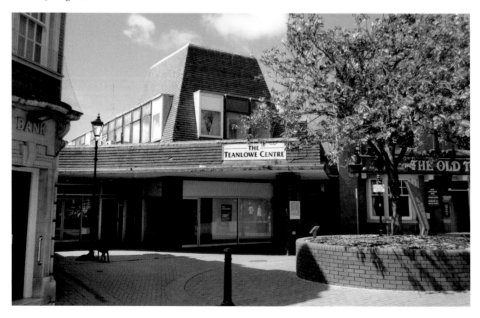

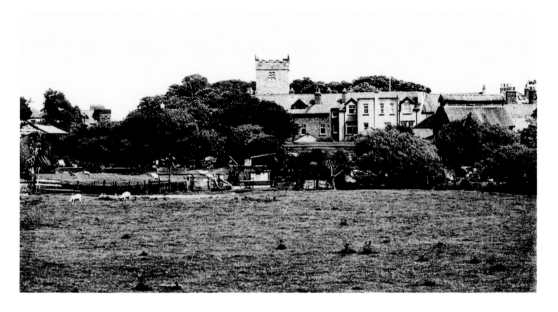

Tithebarn Road Car Park

From medieval times, land around the Market Place had been used as allotments by the townsfolk to produce their own food. In 1848 it was the site of Poulton's first agricultural show. Later, livestock was held here awaiting sale at the Auction Mart. In June this was the site of Poulton's annual gala. During the Second World War the land was turned over to the production of food crops. It now forms one of Poulton's three car parks.

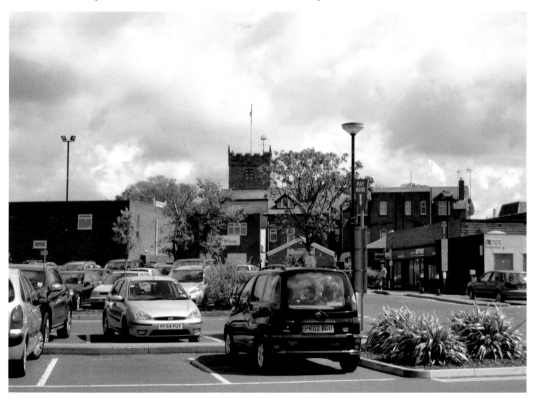

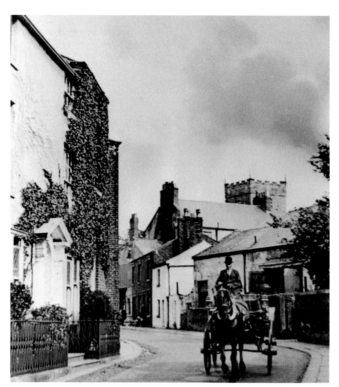

The Tithe Barn

To the right is the tithe barn, demolished in 1968. Its central position in the town suggests it was an ancient site. As their original use came to an end, tithe barns took on various roles. In the 1850s the Poulton barn was being used by James Bleasdale, a carrier, to store goods he was transporting to and from Lancaster. It was used for dramatic performances, and latterly various local tradesmen had their workshops there. All the properties on both sides of the road were demolished in the late 1960s.

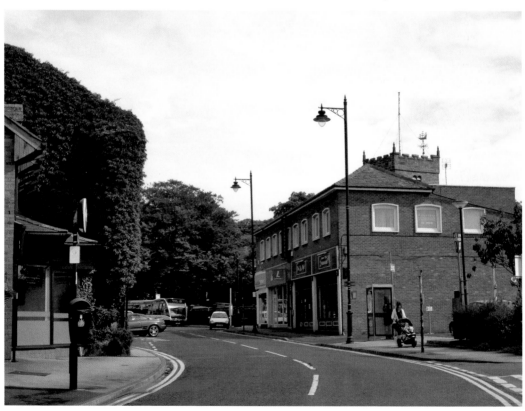

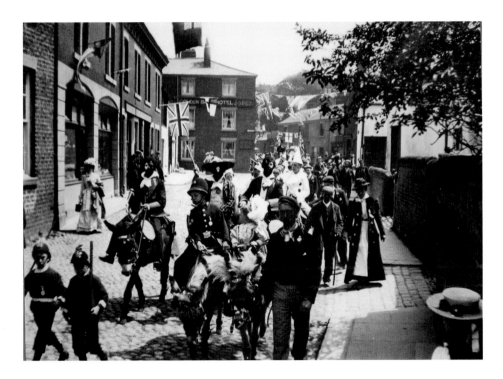

Tithebarn Street Gala Procession

The annual gala procession was an opportunity for all the children to dress up – patriotic themes were most popular. Farmers' horses and donkeys carried riders or pulled carts around the town, here moving down cobbled Tithebarn Street towards Carleton, passing the tithe barn on the right. In the background the properties in Ball Street backing onto the churchyard show that the picture was taken sometime before 1910. In the modern view only the properties on the left have survived in the general demolition of the late 1960s.

Tithebarn Street Car Park Entrance

After some attempts to save it, the tithe barn was demolished in 1969 to be replaced by a car park. Its demolition left a large gap both in the town centre and in its history. Other adjacent shops also went, and were replaced by a new block. The white property beside the Golden Ball, 'The New Penny' was, in the mid-nineteenth century, the house, shop and warehouse of the miller who ran Dick's Mill at Carleton.

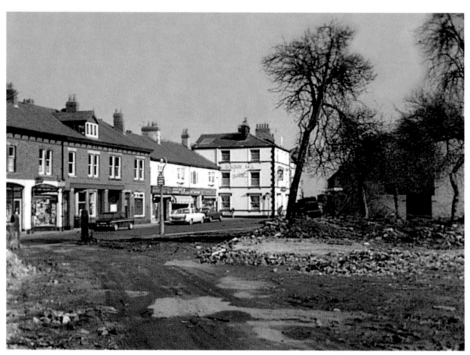

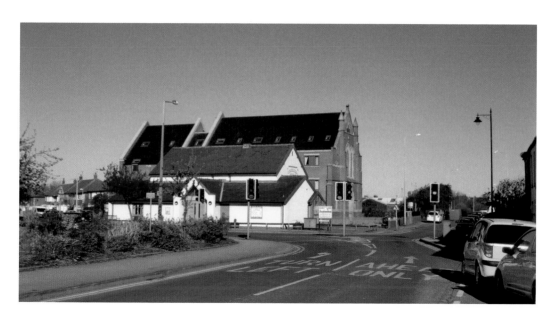

Independent Chapel

In 1809, a 'small commodious Independent chapel' was built on the outskirts of the town. By the end of the nineteenth century membership of the church had increased, and a new building was completed in 1899. The land for the new church was given by a local family whose house, 'Chatsworth', stood close by. In 1973 the United Reformed Church was formed. In 2007, major developments saw the old chapel re-ordered to a prize-winning design and the larger brick chapel converted into apartments.

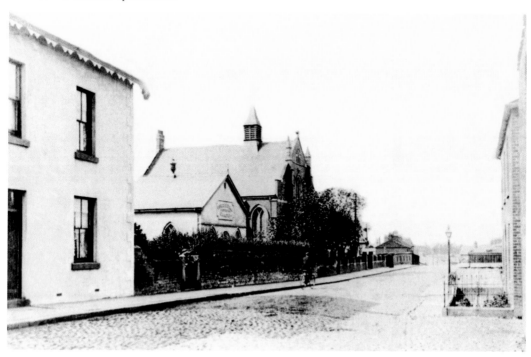

Tithebarn Street Railway Bridge

When the railway line from Poulton to Blackpool was built in 1846, a level crossing was put in place on Tithebarn Street. However, when work began on a new station at the top of the Breck in April 1894, a new crossing point was needed at Tithebarn Street. This time a bridge was built over the line running from Poulton to Blackpool. For this to happen some cottages had to be demolished. Most of the houses in the photographs were built around 1900. More recent building close to the railway bridge, incorporating two shops, completes the modern scene.

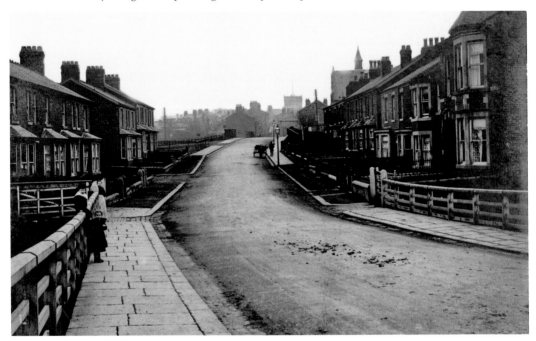

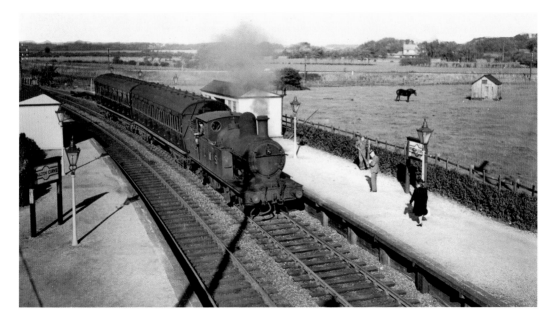

Poulton Curve Halt

A few years after the opening of the station, a new line was opened in 1899 to complete the triangle of lines between Preston, Fleetwood and Blackpool. A small station – Poulton Curve Halt – was opened on this section in February 1909. It closed in July 1952. Alongside the Curve station ran a watercourse known as Horsebridge Dyke, a relic of the countryside before the railway. The line from Poulton to Fleetwood was closed in 1970 and the whole area was landscaped to form a large park and a children's play area.

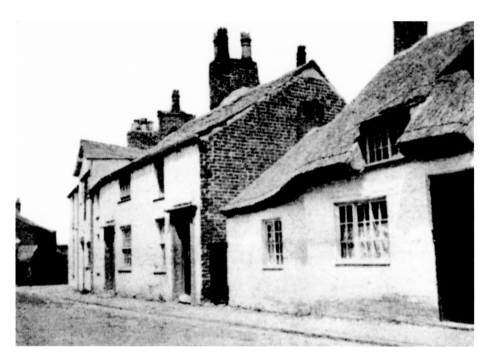

Breck Street Shops

Known variously as the Breck, Breck Street and Breck Road, the view dating from the early 1900s shows brick-built properties next to some much older thatched cottages. When the former were new in 1836 they were advertised for sale – 'each contains a sitting room or parlour, four bedrooms, kitchen, back kitchen'. One pump, 'plentifully supplied with spring water', served all four houses. As part of the re-organisation of traffic flow in the 1970s, the footpaths were widened and the Breck became part of the town's one-way system.

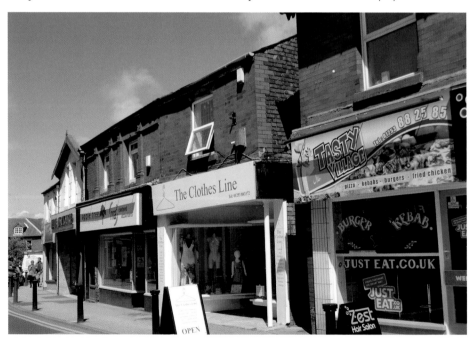

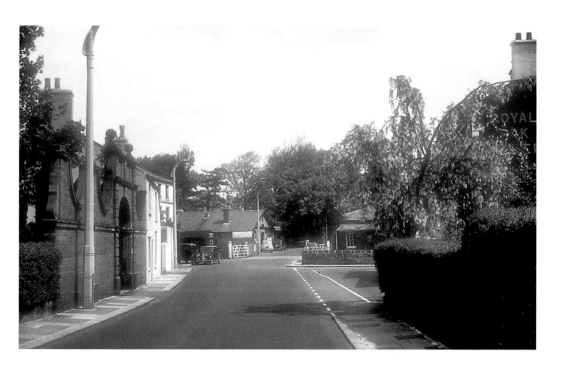

Breck Road and Station Road

At the bottom of the Breck the gates of the original railway station can still be seen in this 1970s view, although the line itself has gone. On the left, the red-brick Jubilee Arch was built in 1897 by Mr Henry Isaacson Parry to commemorate Queen Victoria's Diamond Jubilee. Car repair workshops and Gillaspy's garage, which stood near the railway gates on the left, have been replaced by new apartment blocks. Over the years several plans have been proposed for the development of the old railway land on the right.

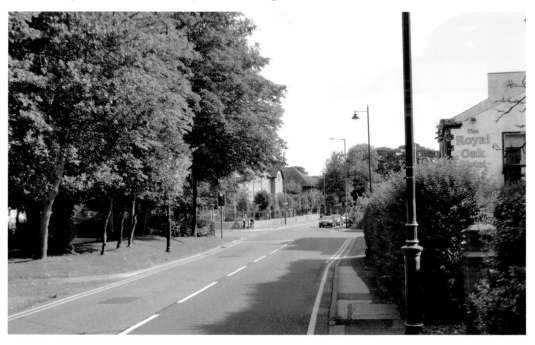

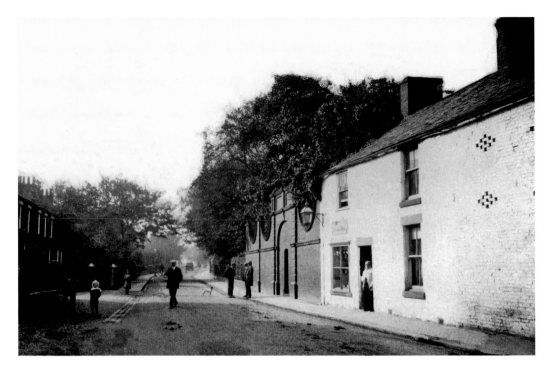

Breck Road Farmhouse

The name Breck comes from the Old Norse word for a slope; the gentle rise to Poulton town centre in the distance is perhaps just discernible in this photograph. The white property on the right was an old farmhouse with around 30 acres of land, much of which was soon to be used for building. The entrance to a small shop – a grocer's and later a baker's – can be seen under the lamp. All this was swept away in developments which were to be significant in Poulton's more recent history.

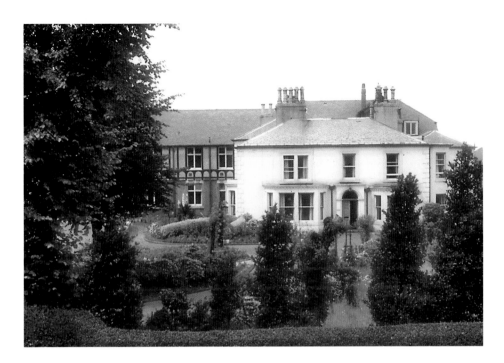

Woodlands

Woodlands was built in the 1890s, behind the farmhouse, by William Parry. Parry Way, a little further down Breck Road, commemorates the family. Many of the houses on Breck Road were large family homes built in the late 1880s. Its position close to the railway station meant Breck Road was becoming a sought-after area of Poulton. In 1932 Woodlands, Parry's home, was turned into a convalescent home and additional buildings were erected in mock-Tudor style.

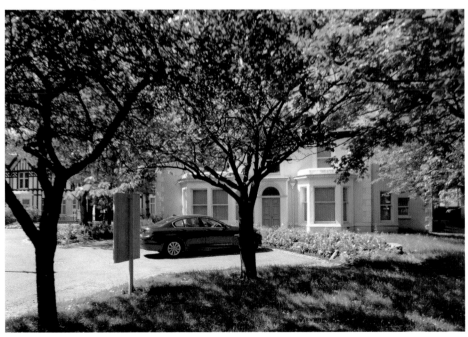

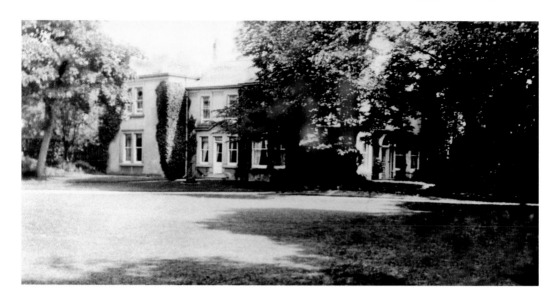

Joseph Cross Memorial Home

The conversion of Woodlands from private house to the Joseph Cross Memorial Home in 1932 involved the demolition of part of the original house. This large extension was added to the west side of the house to provide extra accommodation for the home. Fortunately the design incorporated the existing landscaped gardens, which are still in evidence today. The home was run by a partnership of the cotton operatives' union and mill owners, and was named after a respected member of the union from Blackburn.

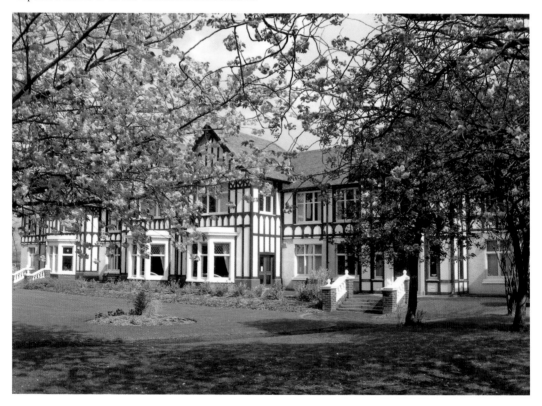

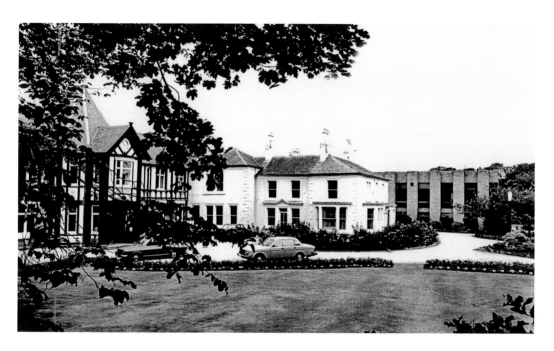

Poulton Teacher Training College

The convalescent home closed in the 1960s and reopened in 1963 as a teacher training college. This development saw the demolition of the neighbouring farm, farm buildings and the Jubilee Arch. The college functioned successfully until 1983, when changes in national education policy lead to its closure. It was suggested it might be converted into a hospital for the elderly, but in 1988 the complex of buildings became the civic centre for Wyre Borough Council.

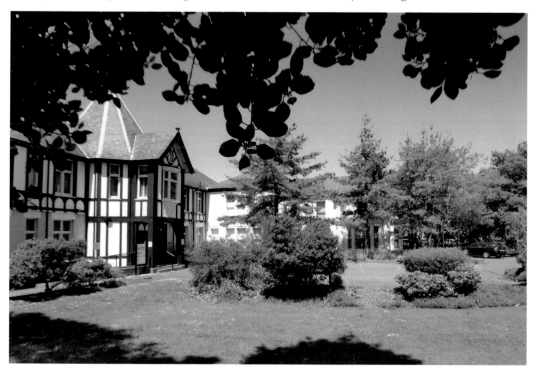

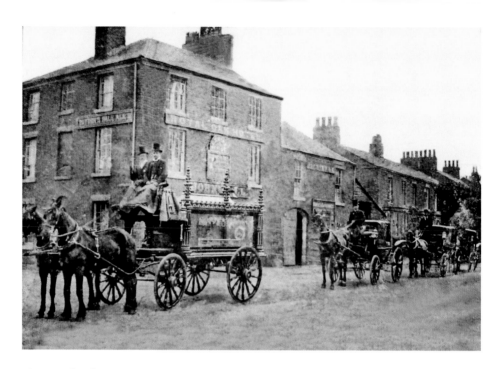

The Royal Oak

This pub, with its typical rectangular design, was built around 1842 on the site of a dye works. It was originally a posting house where coaches would stop, maybe to change horses and refresh their passengers. By the 1880s it had become an excise office, and was advertising 'funerals completely furnished, horses and carriages for hire'. As trade has decreased in recent years, the building awaits conversion into apartments.

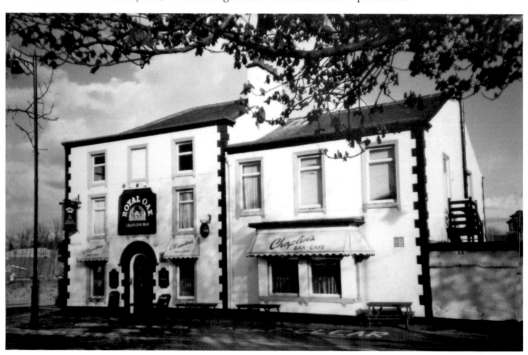

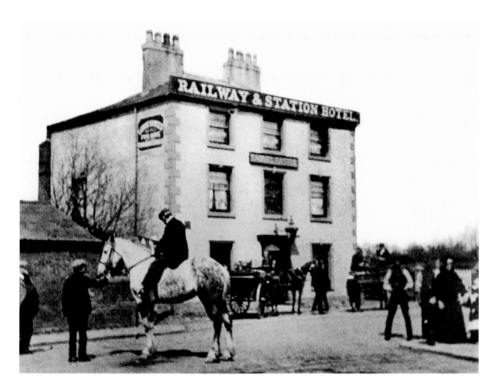

The Railway & Station Hotel

The Railway Hotel was built about 1838 when the railway from Preston to Fleetwood, running through Poulton at the bottom of Breck Road, was being constructed. There were many accidents on the early railways and inquests were often held in the Railway Hotel. Like its counterpart the Royal Oak, standing on the other side of Breck Road, the Railway was a posting house and livestock auctions were held there. By the late 1920s it was no longer a hotel, having been converted into flats.

Breck Road

In the far distance is the old farmhouse, the Railway & Station Hotel and the gates of the level crossing. The railway enabled businessmen to live in Poulton and travel easily to their place of work in towns such as Bolton and Manchester. The white house on the left is Breck Lodge. On the right, behind the gates, stood Breck House, home of James Sykes, a Liverpool wine merchant. The site is now an estate of houses.

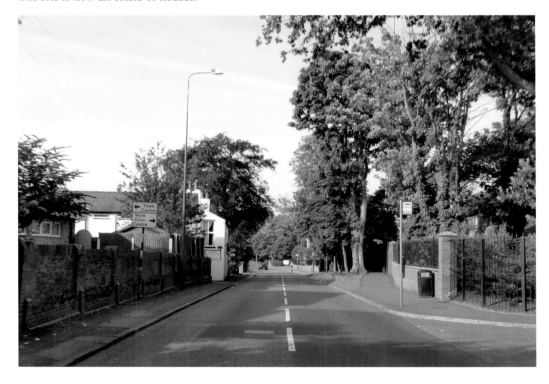

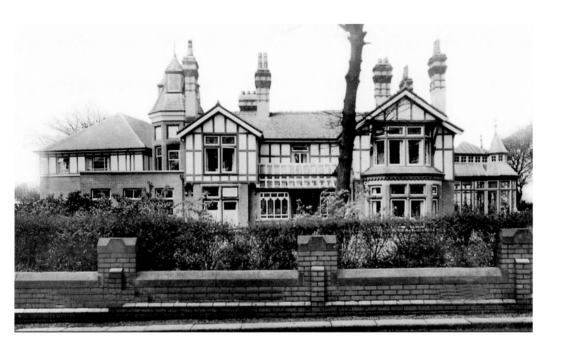

The Mary Macarthur Home

Mary MacArthur dedicated her life to women's trade unionism. By the time of her premature death in 1921 aged forty-one, she had organised more than 300,000 women into the trade union movement. As a memorial to her, holiday homes for working women were set up, catering for guests from many trades and occupations. In the 1980s, across the country the homes were sold and the Mary Macarthur Holiday Trust offered grants to working women who could otherwise not afford a holiday.

Breck House

Shown on a map of 1684 as 'Mr James Pattison's house', during the nineteenth century it was incorporated into the later property known as Breck House. In the 1890s it became a convalescent home – Holly Bank – and later Seafield. In 1945 it was taken over by the Mary Macarthur Trust and opened by the Prime Minister, Clement Atlee. It closed in 1980 and was later replaced by private housing. A public swimming pool and golf course opened in 1974 and are built on some of the gardens.

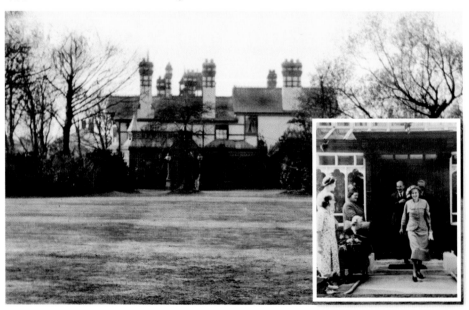

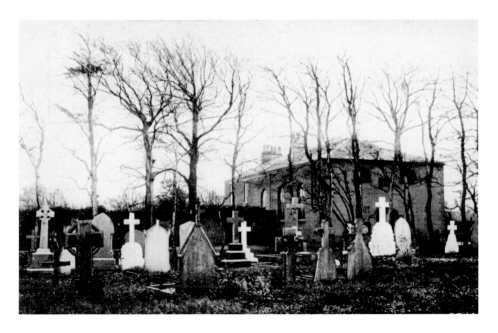

St John the Evangelist Catholic Church – the Old Church

After the Reformation, local Catholics worshipped in Singleton. The congregation moved to worship in Poulton when in 1813 a new church was built at the bottom of Breck Road. It is a simple rectangular shape, designed to be unobtrusive, and it stands at the end of a tree-lined path. One end of the building was designed as a house for the priest. The original graveyard in front of the old church is still used. When the new church was erected in 1912, land in front of the new church also became a burial ground.

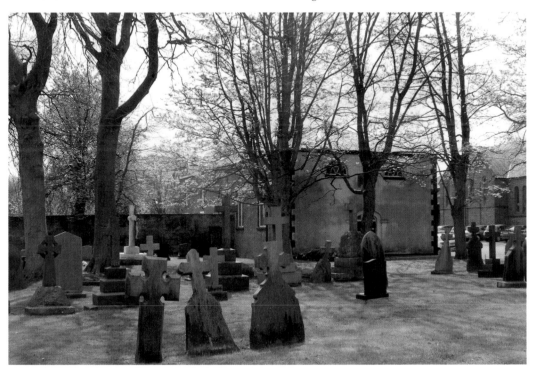

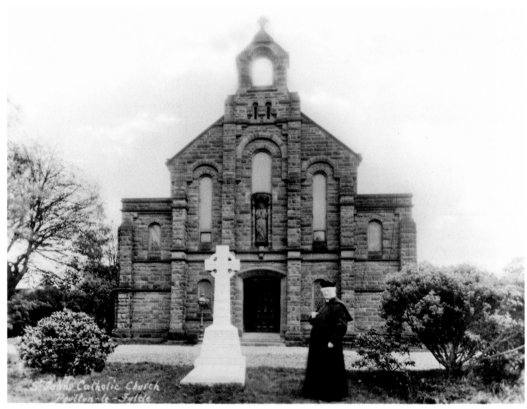

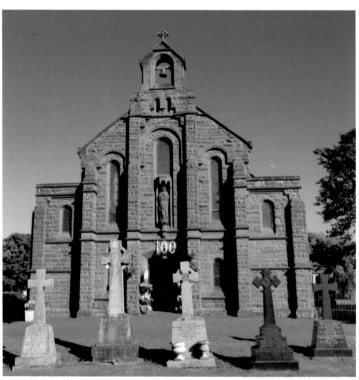

St John the Evangelist Catholic Church – the New Church

Canon Vaughan outside the new church building, opened in 1912. The white memorial cross next to him now carries an inscription commemorating his time at St John's. Born in Ireland, he was priest at St John's from 1900 till 1935 and oversaw the design and erection of the new building, which celebrated its centenary in 2012. The local newspaper reported that it was built in a year and at Canon Vaughan's own expense.

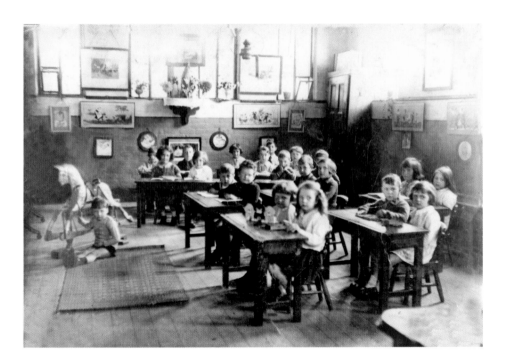

St John's – the Old School

The first mention of a Sunday School at St John's is in 1855. It was held in 'a loft of an outbuilding facing the priest's house'. The day-school opened in 1868 and was run by Sisters of the Holy Child Jesus, who travelled each day by train from their convent on Layton Hill. The old school building was later used as the parish rooms and is now a nursery school.

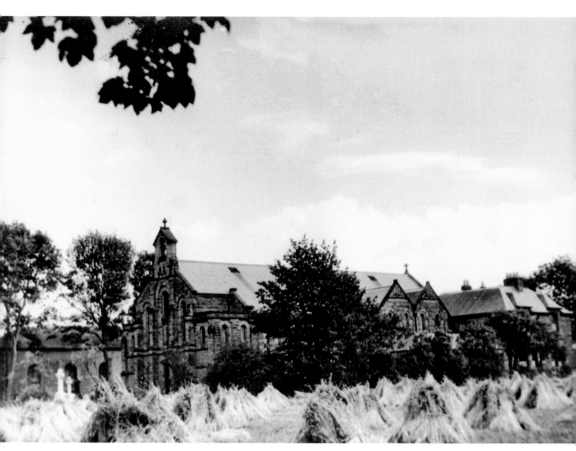

St John's – the New School

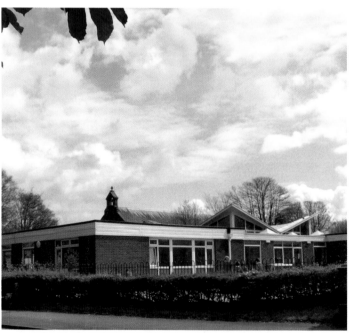

The original church was built in 1813 on land given to the congregation by William Fiztherbert Brockholes of Maines and Claughton. In the late eighteenth century he had purchased a good deal of land in the area of Poulton around Moorland Road. In 1962 the new school was officially opened by the Bishop of Lancaster. It was built in fields next to the church, land which was also part of the original gift from William Fitzherbert Brockholes to St John's.

Alexander Rigby's Town House
Originally built at the end of the
seventeenth century, this property
belonged to Sir Alexander Rigby of
Layton Hall (Blackpool). In 1881, the
house was converted into a branch of
the Lancaster Banking Company. The
firm later amalgamated with others to
become the District Bank. The present
building was erected in 1931 and
is now the Natwest bank. The 1693
date stone from Sir Aexander Rigby's
house is at the base of St Chad's
church tower.

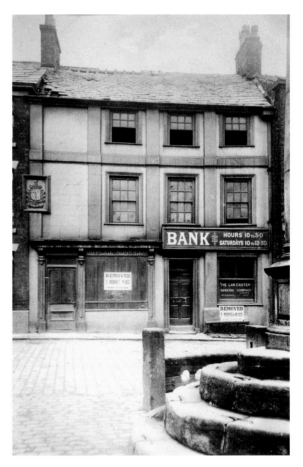

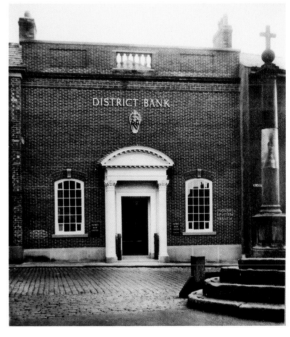

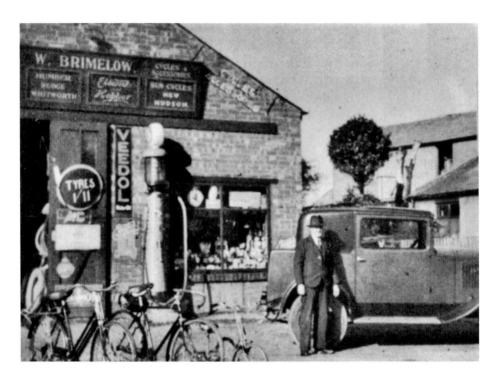

Brimelow's Garage

William Brimelow manufactured steam engines for the cotton industry in Bolton. Moving to Poulton he manufactured cycles, a business continued by his son William, who moved to Highfield House with its stables and trotting track. On this site Brimelow's Garage was opened in 1924, selling cycles, petrol, oil and motor car parts. During the 1950s Brimelow's opened a large car showroom and workshop, and in the 1960s boats and outboard motors were added. Brimelows is the oldest family-owned firm in Poulton.

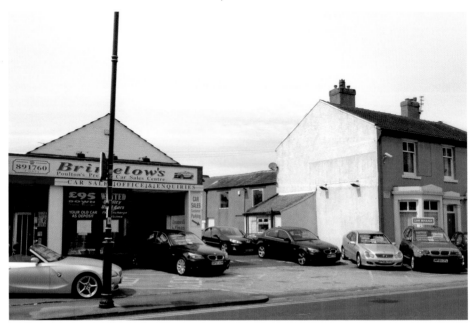

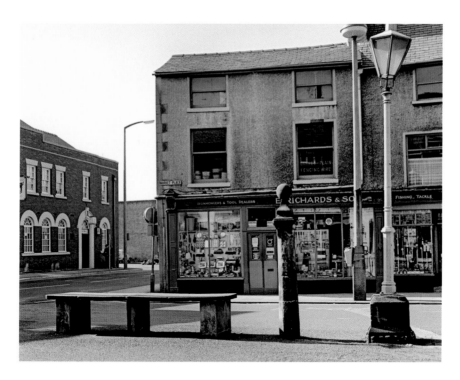

Richard's Ironmongers

This was a well-known ironmonger's business dating back to the mid-eighteenth century, when Ebenezer Richards from Bolton took it over in 1895. Originally selling groceries as well as agricultural goods for the local farmers, it was run by three generations of the Richards family until it closed on 9 November 1979. Since then it has had various tenants. Currently it is the Grapevine, a bistro café and cocktail bar.

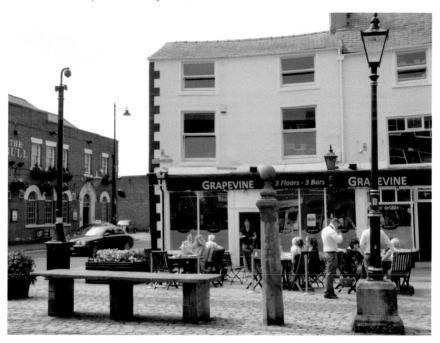

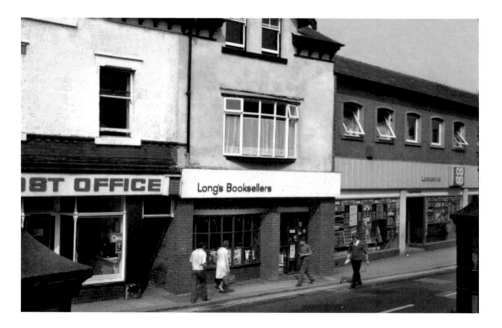

Long's and the Plough Inn

Long's was a well-known Poulton bookshop until the 1990s. This row of shops was erected in 1910, replacing a mix of thatched cobble cottages and early Victorian brick-built shops. This original property in this position was the Plough Inn. An agreement dated 1792 includes rights-of-way to the back in order to thatch the roof. Poulton's post office had many sites, including two different ones in the Market Place. The present post office in the Teanlowe centre, opened in 1977.

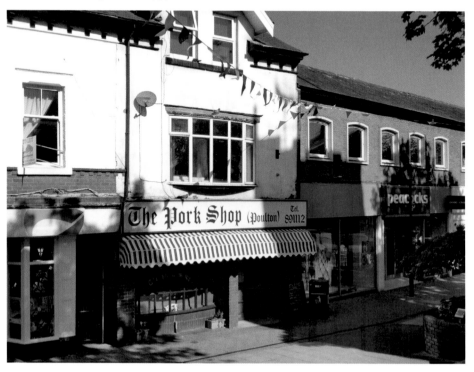

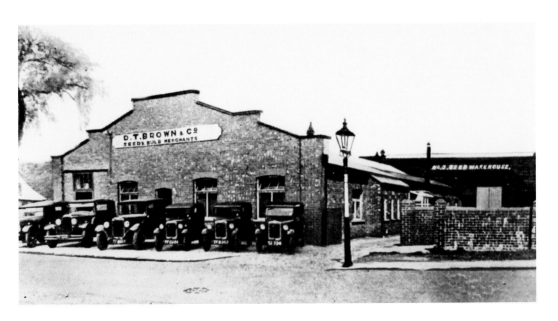

Brown's Seed Merchants

In 1908 David Brown came to Poulton, one of the main horticultural areas, from his birthplace in Scotland and set up a business, growing high-quality seeds for market gardeners and farmers. Poulton's busy market and the fertiliser company at Skippool meant trade was good, and in 1937 land was bought for trial grounds. Here Brown's own selected strains of seeds were produced. In 1994 Brown's became part of 'Mr Fothergill's Seeds', based in Newmarket. The property is now Clancy's car body workshop.

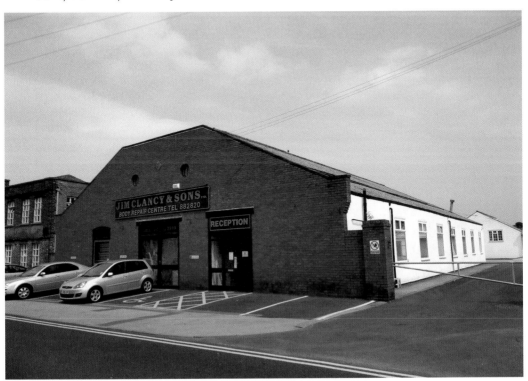

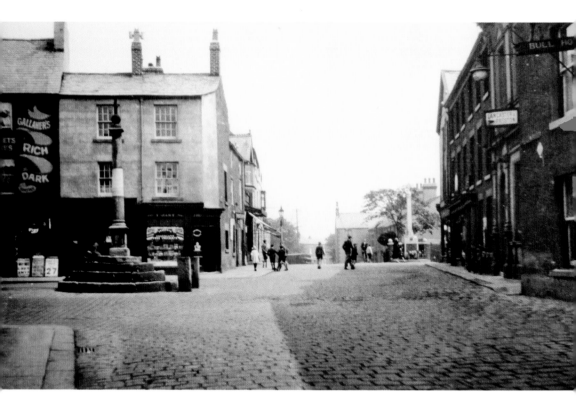

Hart's Corner Shop

The corner shop behind the market cross belonged to Hart's, who ran a dairy there from 1918. The milk round was sold in 1955, and when Thomas died the following year his widow, Lizzie, continued running the shop, selling groceries, tobacco and confectionery. She died in 1975. In 1991 when the building was found to be structurally unsound, it was demolished and rebuilt using some of the original bricks and retaining the original shop-front.

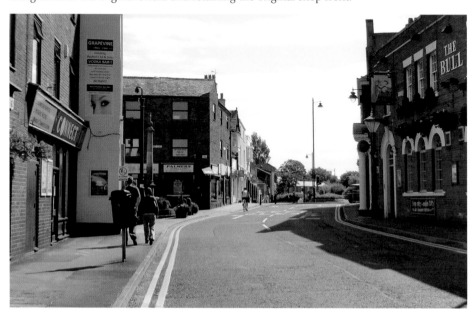

The Wesleyan Chapel

The first Methodist chapel was built here on the corner of Queens Square and Back Street (now Chapel Street) in 1819, only the second one to be built in the Fylde. In 1861, a Sunday School was opened and the chapel enlarged. The new church on Queensway was opened on New Year's Day 1965. The following year this building was demolished. The corner shop, Thomason's grocers, has also been a café and is now a dentist's.

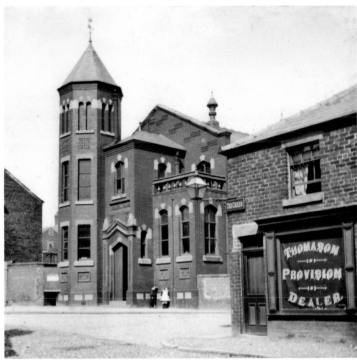

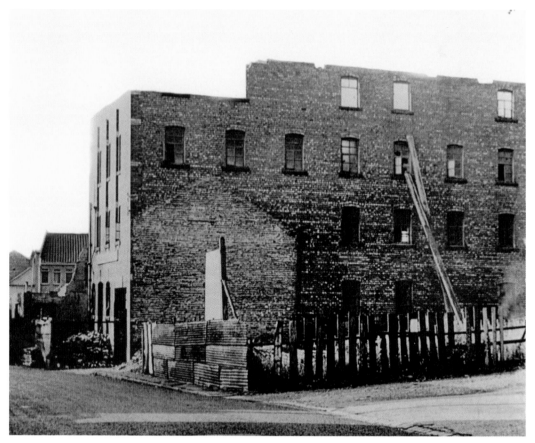

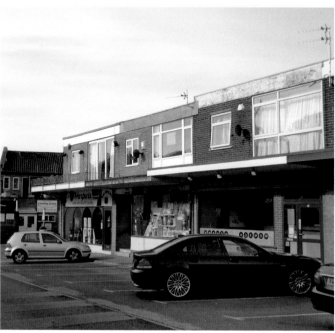

Parkinson Tomlinson's Mill

This five-storey brick corn mill stood on Chapel Street until it was demolished and replaced by a row of shops in the early 1970s. In 1879 William Tomlinson married Agnes Parkinson, and so began the well-known Parkinson Tomlinson family. W. & J. Pye took a controlling interest in Parkinson Tomlinson's mill, which ran as a separate business until May 1962, when it was absorbed into the main business. Parkinson and Tomlinson was finally wound up in 1970.

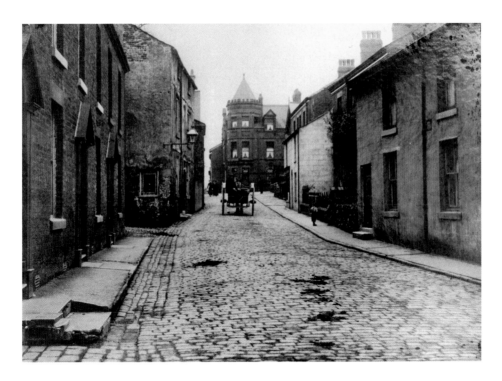

Chapel Street

Once known as Back Street – running at the back of the Market Place – it became Chapel Street when the Methodist church was built. Until the mid-nineteenth century, there were several gardens in the street where householders would grow their own produce. The terrace of houses on the left was built on gardens. While the properties on the right are still standing, virtually everything on the left has been replaced. The pinnacle on the Ship Inn has disappeared.

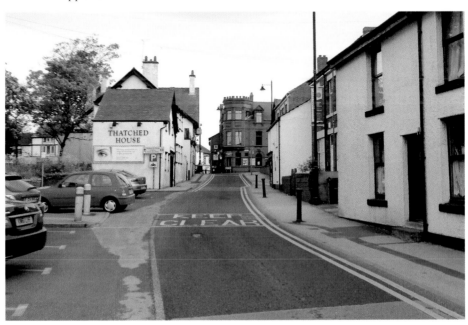

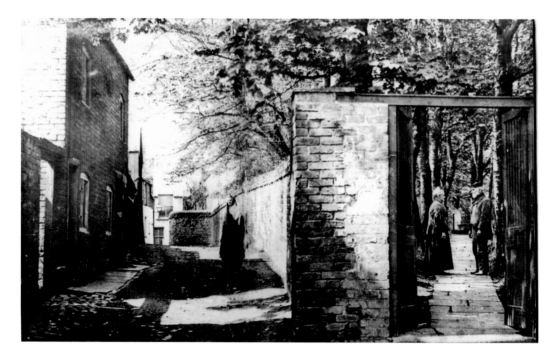

Potts Alley

This walkway links Chapel Street with the Market Place and was also known as Potts Entry. In 1848 a report on the town's public health described Potts Alley as having 'pigstyes, rats and a common privy in an indescribable state'. Houses once backed onto the churchyard at the far end; their doorsteps are still visible, incorporated into the brick wall. By 1900 it had been renamed Chapel Street Court, and it is now lined with shops, restaurants and coffee shops.

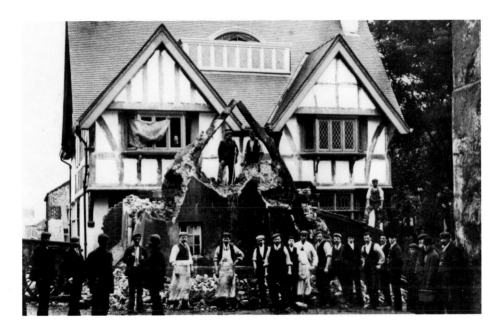

The Thatched House

The demolition of the old Thatched House pub is underway as the new building is being completed around 1910. This marvellous photograph shows the stark contrast in size between the old and the new. The landlord, Nicholas Charnock, can be seen looking out of the first-floor window. The original cruck-framed building stood at right-angles to Ball Street. A pub was often to be found at the gates to a church, offering refreshment for those travelling long distances.

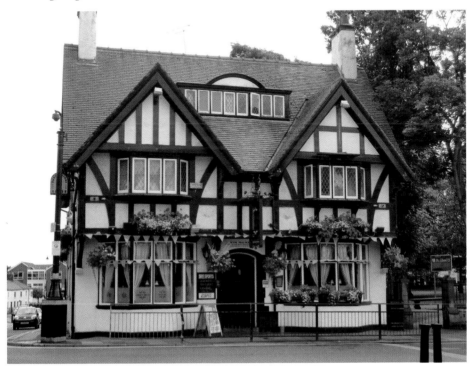

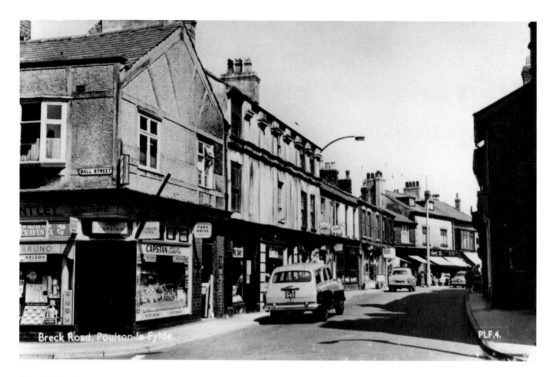

Breck Road

The junction of Ball Street and the Breck. In the 1950s the shop with its door on the corner was a tobacconist's run by Gordon Bentley. Before the war Thomas Birkbeck had a gents' hairdresser's here and sold 'smokers' requisites'. In the mid-nineteenth century the three-storey property was the home of Giles Thornber, whose son William wrote a history of Blackpool, printed in Poulton in 1837. It is difficult to imagine two-way traffic using this road today.

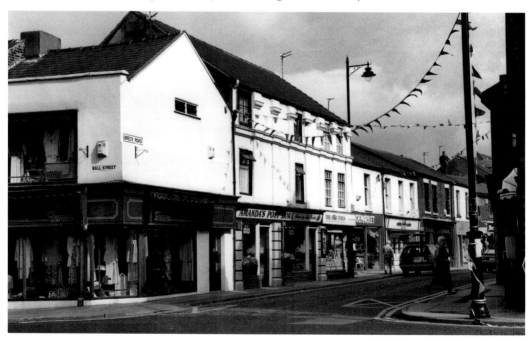

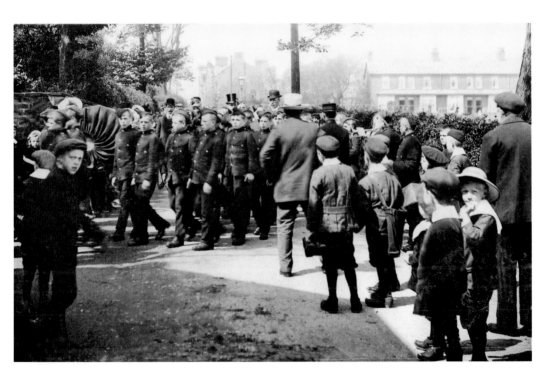

Vicarage Road

The Fylde Farm School for young male offenders was opened in Hardhorn in 1904. The school band played at many local events, and is seen here turning into the vicarage gardens after the memorial service for King Edward VII in 1910. In the distance can be seen the imposing red brick of the Ship Inn, together with the houses on Prudy Hill. Vicarage Road was still a country lane. The Rialto cinema, now a nightclub, was opened in 1917.

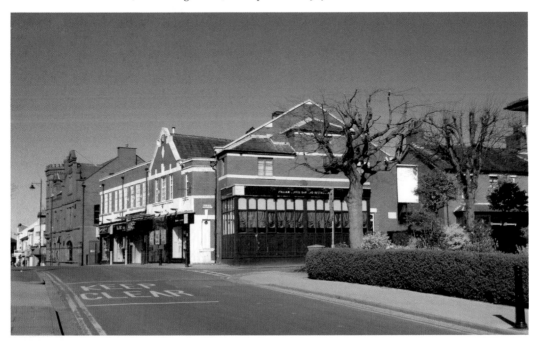

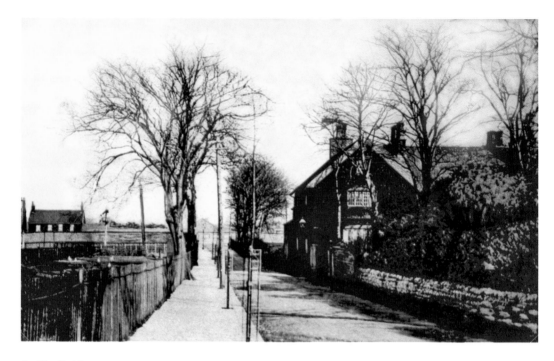

St Chad's Vicarage

In 1835 this new vicarage was built, replacing an ancient cruck-built house of two storeys with an upper floor open to the roof. During the First World War, the vicarage was used as a military hospital for men recuperating from the fighting. In the distance can be seen the railway bridge on Station Road. The present vicarage was built in 1963 and stands to the right of this scene.

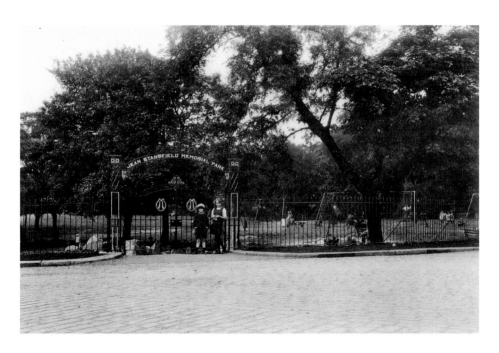

Jean Stansfield Memorial Park

Nine-year-old Jean Stansfield died suddenly on 27 September 1923, the only child of Mr & Mrs S. F. Stansfield. The couple bought a piece of glebe land from the church, and on 17 June 1926 a children's park was opened, dedicated to their daughter and bearing her name. Some years later the Stansfields agreed to the deeds to the park being altered, and the town's first public bowling green was opened on the land in June 1938.

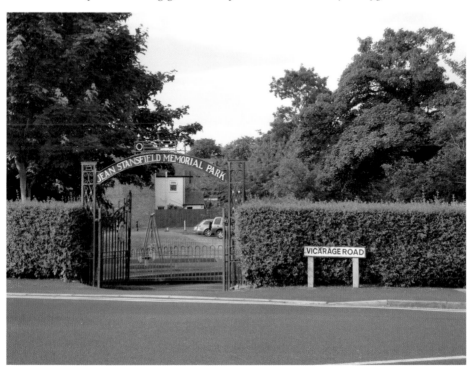

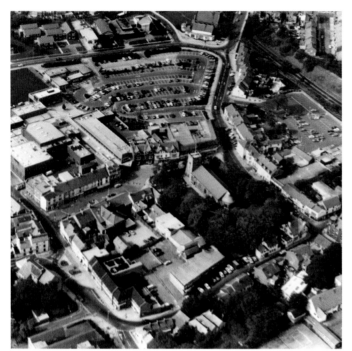

Poulton Town Centre
The simple, rectangular town centre with roads leading off to the neighbouring communities is clear in this photograph taken in 1932. St Chad's church is surrounded by trees, with the church hall on the centre-right. In the late 1950s much of the surrounding agricultural land was used for housing, and the late 1960s saw a major demolition and rebuilding programme take place in the town centre. The result of this is clear in the photograph of 2009.

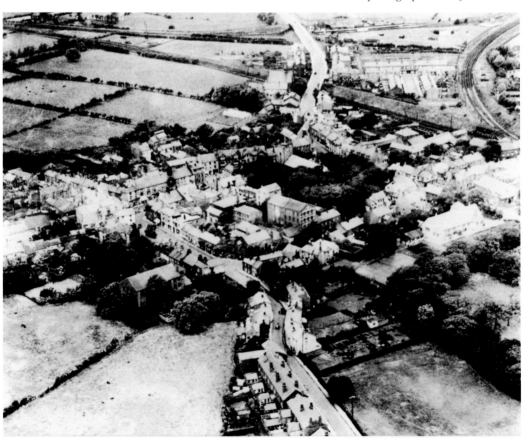

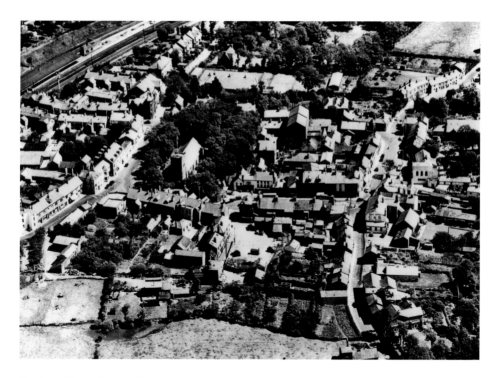

Poulton Town Centre Plans

The basic shape of Poulton's town centre has remained unchanged for centuries – a rectangular market place with the parish church at one end. During the late 1960s major redevelopment took place in Poulton and several plans, such as this one, were put forward, proposing to rebuild the entire town centre. Most properties at the back of the west side of the Market Place were demolished and replaced by car parks and the Teanlowe shopping centre.

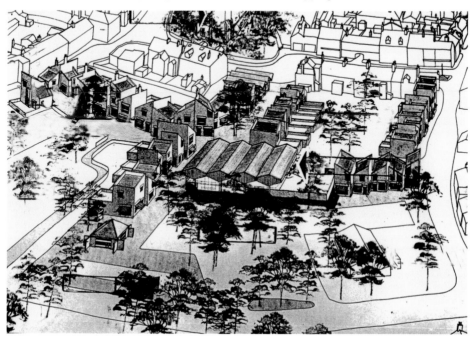

Blackpool Old Road

This typical Fylde cottage, originally thatched was demolished in the late 1960s as part of the rebuilding of Poulton town centre. The library stands on the same site, opposite the home of Sir William Hodgson. In the 1930s, when this property – then named Dudley Hall – came up for sale, he bought it to prevent anyone building on the site opposite his house. The chimneys of what is now the corner house on Queensway can be seen over the cottage roof.

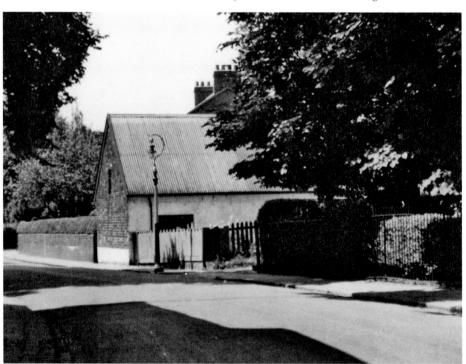

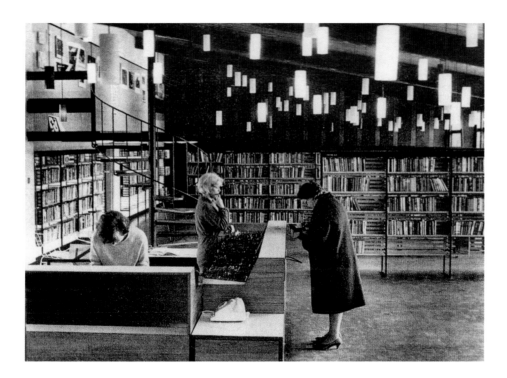

Poulton Library

In 1887, a library was opened for one afternoon a week in the Savings Bank on Vicarage Road. In the early twentieth century the library was housed in Poulton Town Hall, and in 1935 it moved to the old court house building in Queens Square. In those days Poulton Library was staffed by volunteers. As part of the town centre rebuilding programme, the present library was erected in 1964. In 2009 the interior was redesigned.

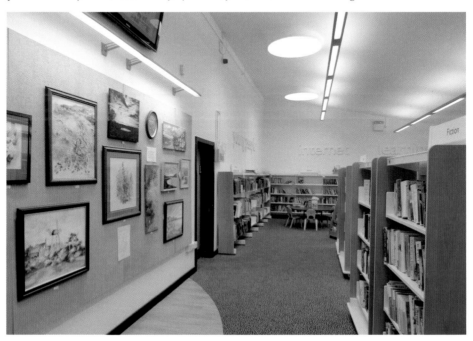

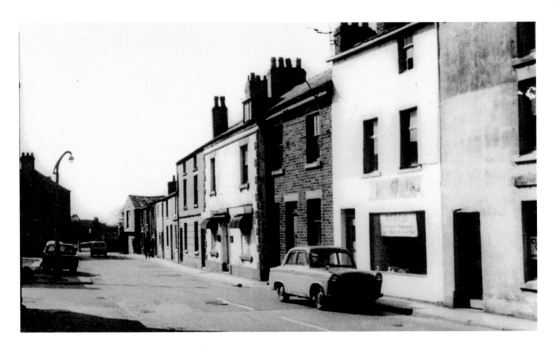

Blackpool Old Road – Formerly Bull Street

On the right with the window blinds is the Sportsman's Arms, previously a beer seller's, later the Merry England café. Bull Street was the home of many of Poulton's craftsmen and artisans – nail-makers, bonnet-makers and seamstresses, shoe- and clog-makers and agricultural labourers. In the early 1970s the whole row was demolished and replaced by a bus depot, the entrance to the Teanlowe shopping centre and the blank brick wall of a supermarket.

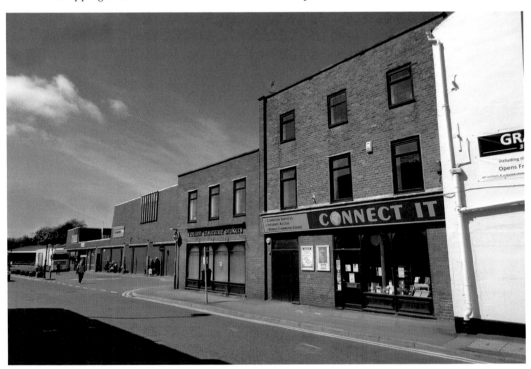

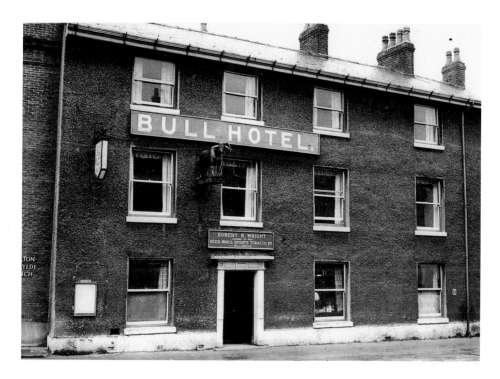

The Bull

Originally the Black Bull, in the 1840s this was a large establishment, with a brewhouse, stables for forty horses, a large barn and a bowling green. Inside were twelve lodging rooms, three parlours and a dining room with seating for 150. In 1955 the Bull was rebuilt and it appears that at that time the large figure of a bull disappeared from the front of the building.

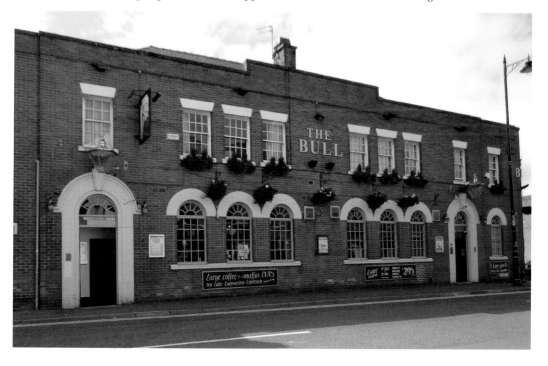

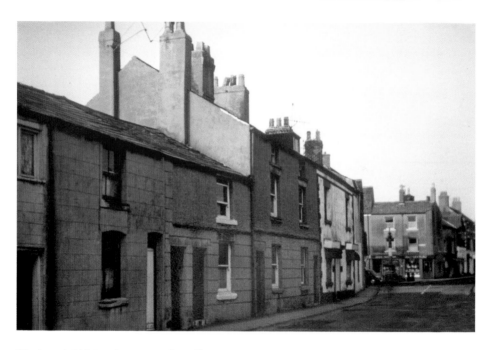

Blackpool Old Road – Formerly Bull Street
Looking towards the Market Place and Queens Square, the white building on the left is the Merry England café. During the 1970s, the row was replaced by red-brick shops and offices of various heights, the slightly changed building line allowing a partial view of the back of the eighteenth-century row on the west side of the Market Place. The white building in the far distance was the Spread Eagle Inn.

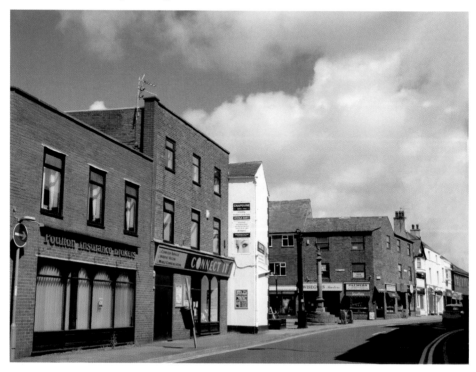

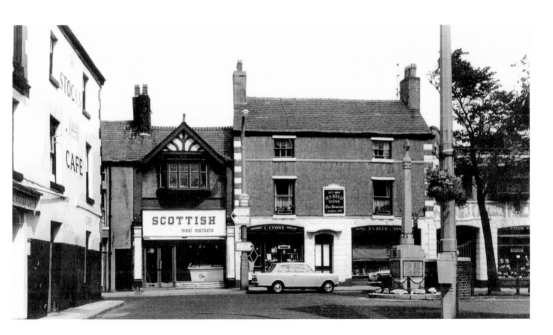

The Spread Eagle

The design of this former coaching inn – the Spread Eagle – is clear, double-fronted with a passageway to the side leading to the stables. It closed during the early nineteenth century and it became a baker's and bread shop and later a grocer's. At one time it was run by Parkinsons – the name can still be seen in tiles below the window. In this property there had been a café and the registrar's office, with a jam factory at the rear.

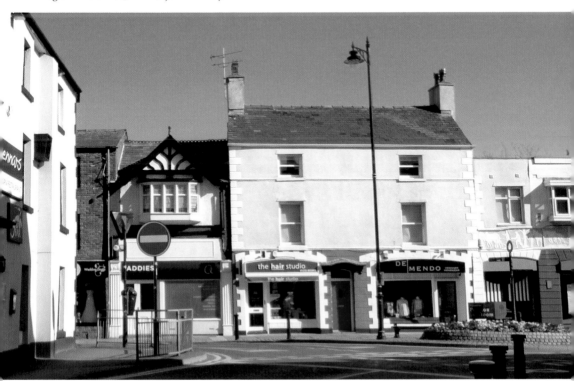

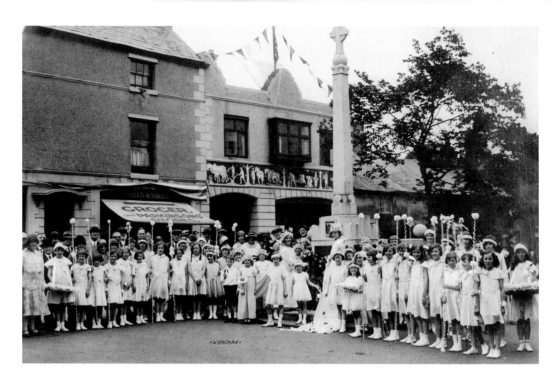

Queens Square and the War Memorial

Typical of the Poulton townscape is this mix of property on the north side of Queens Square, built at different times and in different styles. The frieze under the window on the left represents the four seasons. A row of four cottages seen in the background was replaced by Poulton Laundry in the 1960s. The whole row was demolished in the early 1970s to be replaced by shops and a supermarket. The war memorial was erected in 1923.

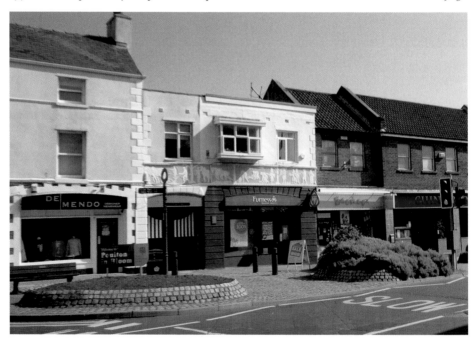

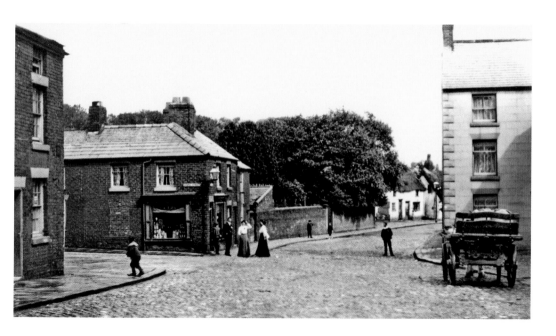

Queens Square and Higher Green

From Queens Square the road ran past the town green and on to Singleton. The land at the back of the white cottages in the distance was glebe land belonging to St Chad's parish church. The cottages were typical Fylde houses, built of cobbles from the shore. All the roads and squares were also cobbled. Large, expensively furnished town houses in Queens Square contrasted with the humbler cottages on the Green.

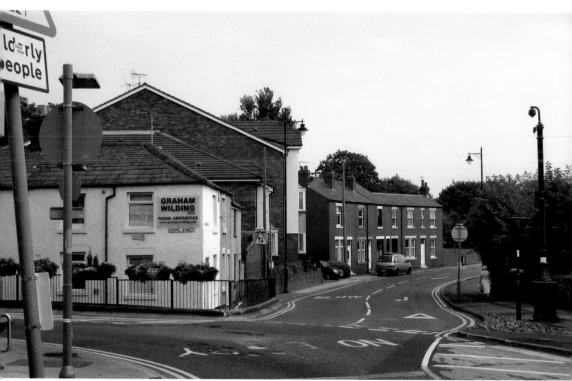

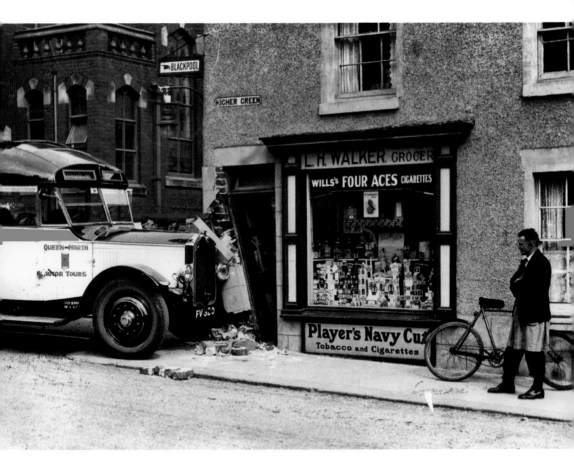

Bus Crash

In the late 1930s a Methodist Sunday School trip to Knott End was stopped abruptly when two young boys, lifted into the driver's cab out of the way for a short time, found a big stick near the driver's seat. Unfortunately it was the handbrake, and when they moved it the bus gradually made its way down the slope into the corner shop. Redecoration work done recently on the corner property found undetected structural damage caused by the crash.

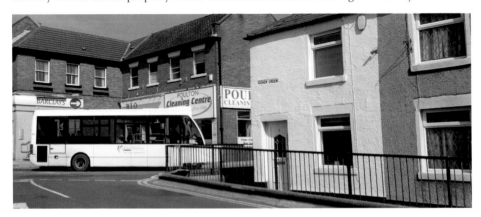

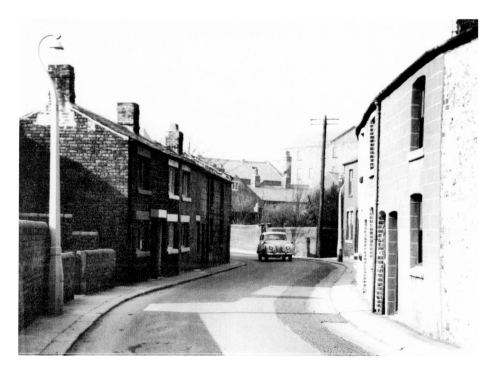

Higher Green

A view of Higher Green, looking towards Queens Square in the 1960s. In the distance can be seen the towering Parkinson Tomlinson mill building in Chapel Street. To the left, out of shot, stood Queens Brewery. In the 1840s a smithy stood at the back of the cottages on the right. Virtually all of these buildings have gone, to be replaced on the left by single-storey sheltered accommodation and on the right by three-storey apartment blocks.

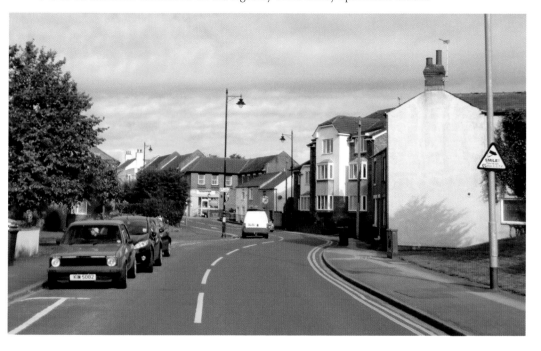

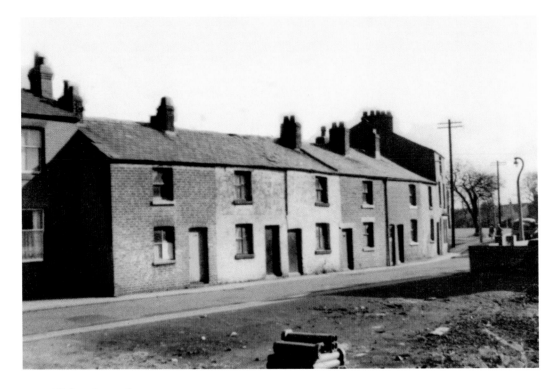

Higher Green Cottages

Now known as Higher Green (and further along Lower Green), the whole of this road was originally called simply 'the Green', an indication of its original use. The land between Vicarage Road and Station Road, once St Chad's glebe land, is now Vicarage Park. Soon after this picture was taken in the late 1960s, all these properties were demolished. The three-storey property at the far end of the row included a grocer's shop.

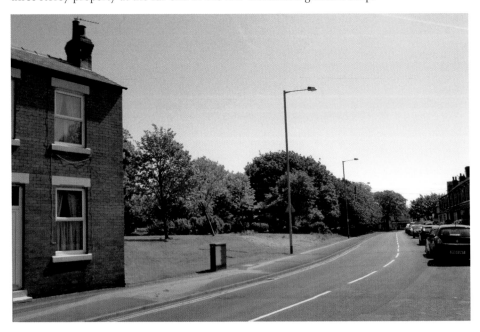

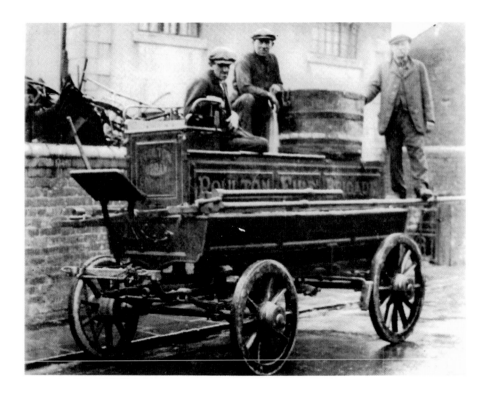

Fire Engine on Higher Green

Taken in the 1930s, the photograph shows Ike Ismay on the right, with Harry Kay and Jack Carter, outside his house, 20 Higher Green. Ismay had bought the Poulton fire engine for scrap. Isaac Ismay, a well-known local character, was born in Cockermouth and died in Poulton in 1947, aged ninety. Labelled 'Poulton Fire Brigade', this horse-drawn steam-pump fire engine is typical of those built in the late nineteenth century.

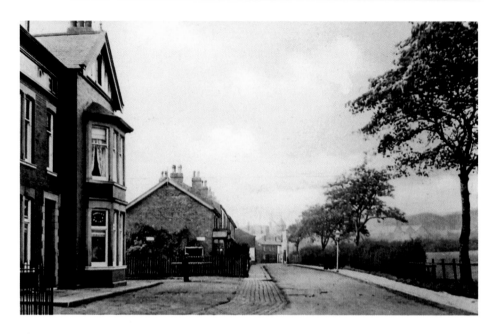

The Queens Hotel – Berkley Court

The Plough Inn in Church Street ceased trading as licensed premises when the Queens Hotel in opened in 1901. The Queens was built on a plot of land beside a short road that led to a nursery. After the war the surrounding land was compulsorily purchased and the Princess Avenue estate was built on it. In 2004 a block of nineteen apartments was built on the site where the Queens had stood.

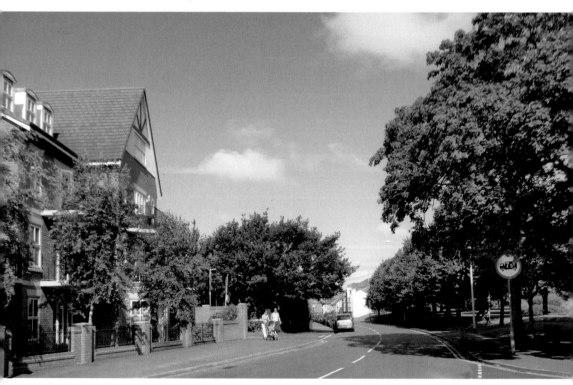

The Nine Houses

This terrace on Lower Green consisted of nine two-up-two-down houses. Although without bathrooms and with a WC in the yard at the back, they made comfortable homes. In spite of much opposition at the time, the properties were compulsorily purchased in 1976 by Wyre Borough Council to make way for new council housing and landscaping, a project planned to improve the whole area around Regent Terrace and the newly built houses in First Avenue.

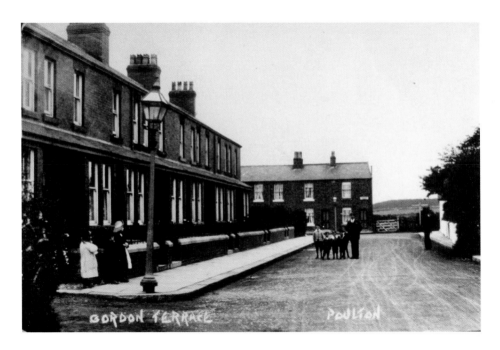

Gordon Terrace

This terrace was built about 1887 and named to commemorate General Gordon of Khartoum. The houses in the distance are on the old road which ran from Little Poulton to Oldfield Carr. When the new road from Blackpool was built, bypassing Poulton, this old road was renamed Argyle Road. In the 1990s the Garstang Road end of Lower Green was widened and the end house was demolished.

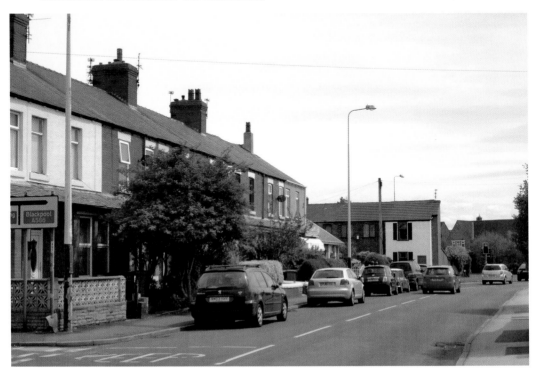

Greenbank Farm, Argyle Road

In the eighteenth century this consisted simply of a small cottage with a garden and a meadow. By the 1830s, a new house had been built on the site and several fields purchased to form a substantial farm with a barn, stables and a shippon. In 1989 the old farm and its outbuildings were demolished and twenty-one flats were built on the site.

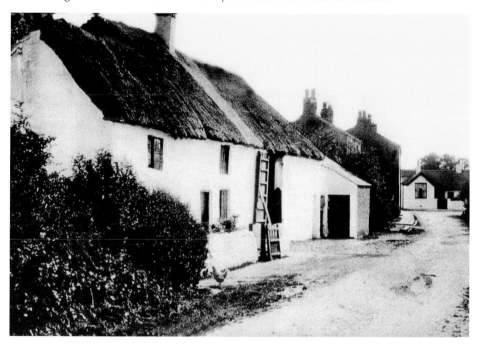

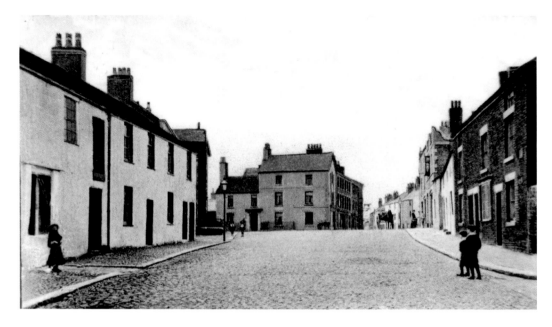

Queens Square

The house on the extreme left was the home of John Bowman, the first secretary to the very well-supported Fylde Temperance Union. The only property remaining from this scene today is the at the far end – for many years the Stocks Restaurant. This was known once as Workhouse Square, as a large house on the left (not visible) was used to provide employment in weaving sheds at the back.

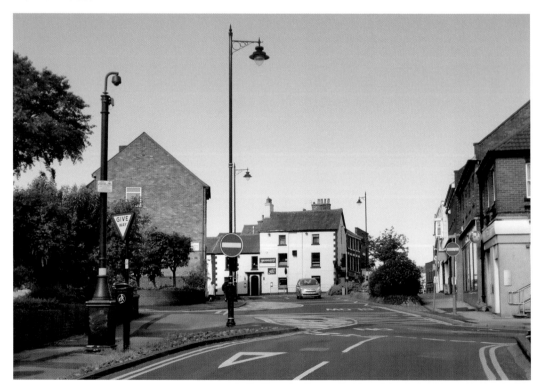

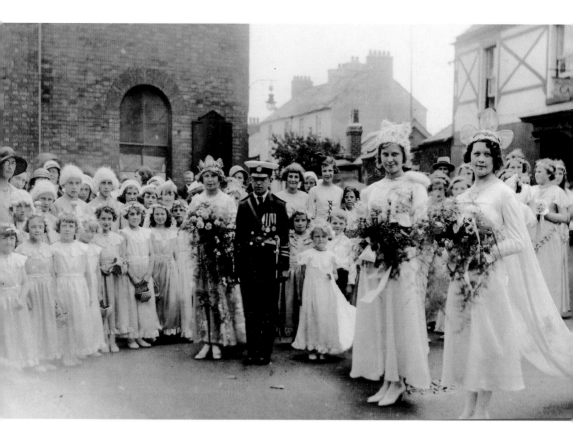

Queens Square and Hardhorn Road Corner

The corner of Queens Square in the 1930s, with the old library on the left and what became the Stocks café on the right. The earlier picture pre-dates the extension that was later added to the Stocks building. Decorating buildings with wooden strips was a popular fashion, carried out in the 1920s and continued on the west side of the Market Place. The houses in the distance were demolished in the 1960s.

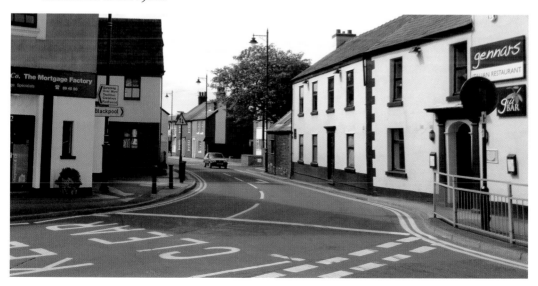

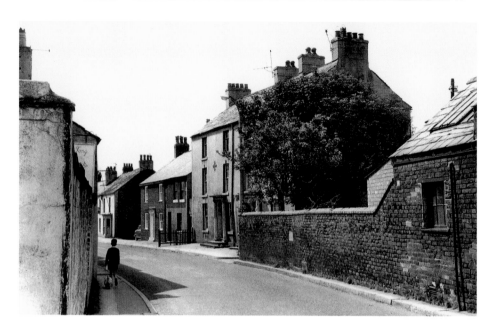

Sheaf Street

Another example of the mix of buildings in the town. A pair of double-fronted three-storey houses stand alongside smaller properties. In the late 1960s the larger houses were reportedly found to be in a poor state and were demolished, along with part of the old brick wall. A block of flats and a block of offices now stand in their place. The east side of Sheaf Street has a similar mix of two- and three-storey properties.

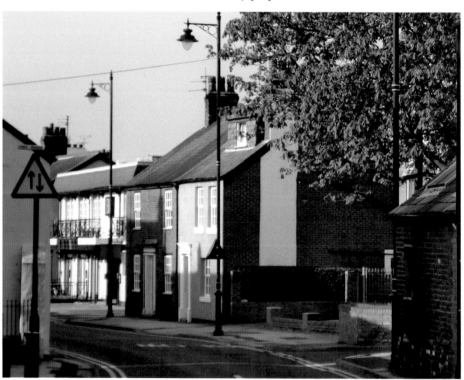

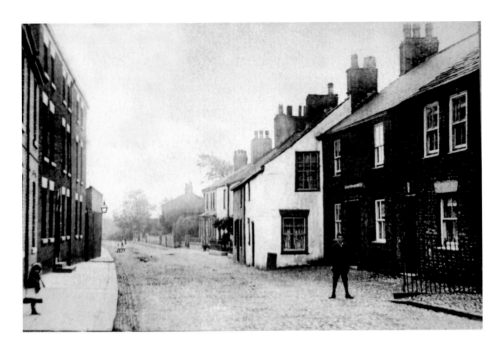

Samuel Lomas

The house on the right with the red door was the home of Samuel Lomas, Poulton's clockmaker between 1744 and 1792. Documents refer to the 'smithy' – a small outbuilding at the back of the house which served as Samuel's workshop and which still exists. The house included a right-of-way at the rear of the next property. The much older white cottages on the right hide the Wheatsheaf Inn. The properties on the left still remain, but many of those on the right have been replaced.

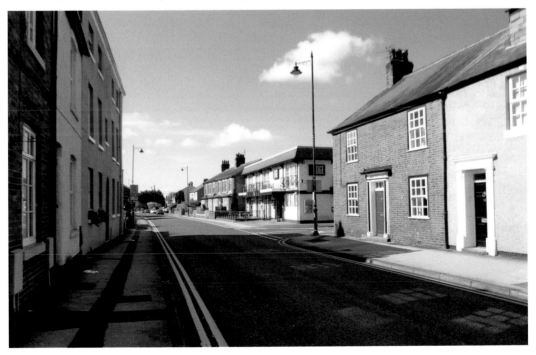

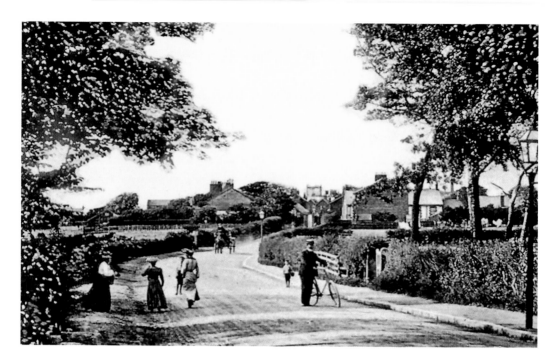

Hardhorn Road

This ancient country road ran between Poulton town centre and the small neighbouring communities of Hardhorn, Newton and Staining. It was one of six similar route ways leading from Poulton into Carleton, Singleton, Layton, Skippool and Little Poulton. This whole area was farmland and Poulton was the market and main commercial centre until the late nineteenth century. Garstang Road – originally named Poulton New Road – was opened in the 1920s, bypassing Poulton town centre. It was the first route near Poulton to run in an east–west direction.

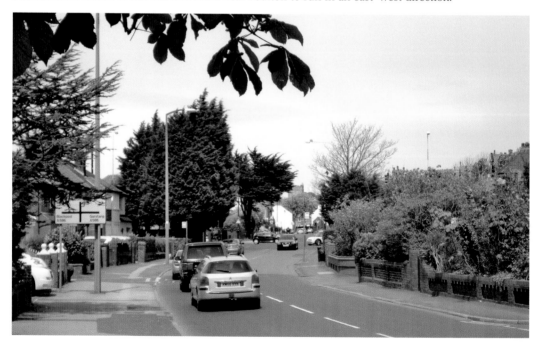

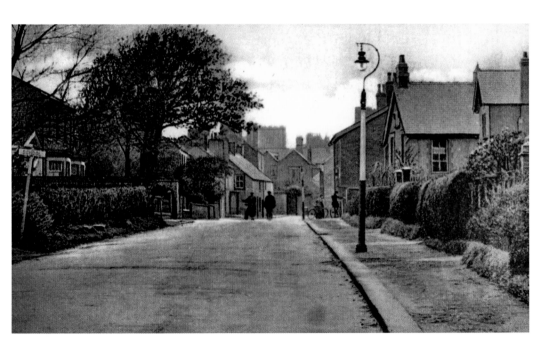

Sheaf Street School

In 1830 a large Sunday School was built on a plot of land which had been a garden belonging to an ironmonger, Thomas Threlfall. As was the custom, the school had been paid for by public subscription and replaced the small cottage on the Green where children from St Chad's had gathered on Sundays. The school was always known locally as Sheaf Street School, but is now St Chad's C of E Primary School. The mix of houses on the left illustrates the piecemeal development of this older part of Poulton.

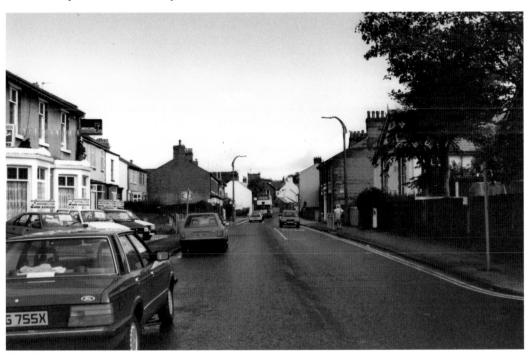

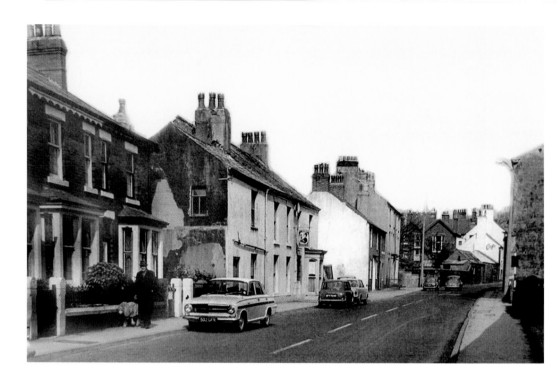

The Wheatsheaf Inn

Nothing remains of the Wheatsheaf apart from a description written in the 1930s. During the early nineteenth century the inn was run by Richard Parkinson. When Richard, his wife and eldest son all died in the 1850s, records show that the inn became a private home – Lindum House – with stables, gardens and a vinery. Here Lindum Terrace was built in 1896. Before demolition the old pub became the telephone exchange, then the Comrades Club. In recent years the property which replaced it has been a variety of nightspots.

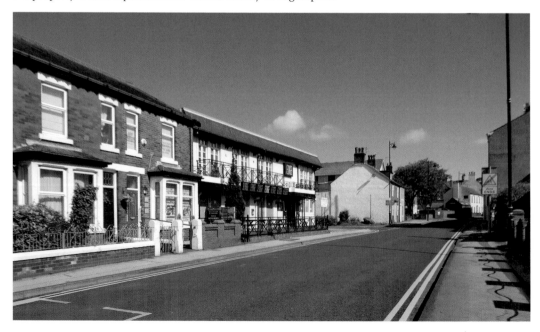

St Chad's Church Clock

The oldest photograph yet found of Poulton Market Place. The church clock was replaced and moved from this low position on the tower to its present higher one in 1865, when the old clock was found to be 'completely worn out'. Samuel Lomas maintained the old clock for over fifty years, until he died in 1792. The bottom step of the market cross shows how much the level of the Market Place has risen over the years.

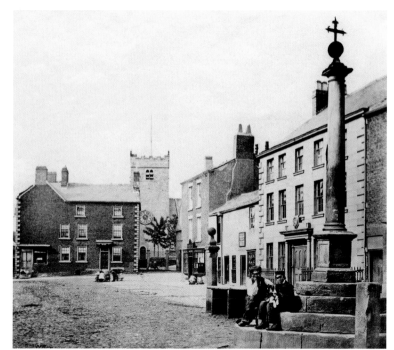

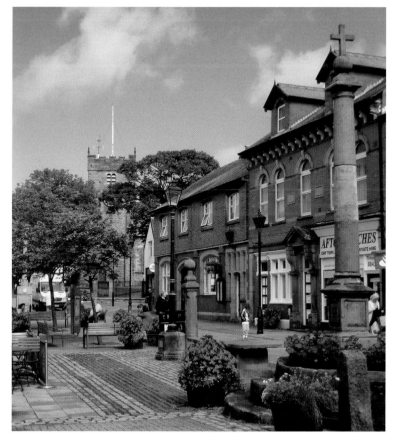

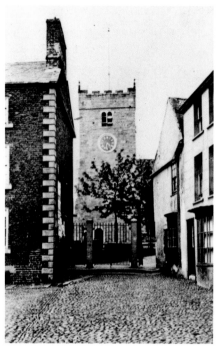

St Chad's Gates

The churchyard was surrounded by various buildings until they were demolished in 1910, but the property on the left remained until 1938. It had been a house and shop, a 'Cyclists' Rest', and finally a bank. On the right is some of the oldest property in Poulton, though it has been much altered over the years. Ancient bow windows can be seen in the shops on the right. There are more steps in the modern photograph; it appears that here the level of the Market Place has dropped over the years.

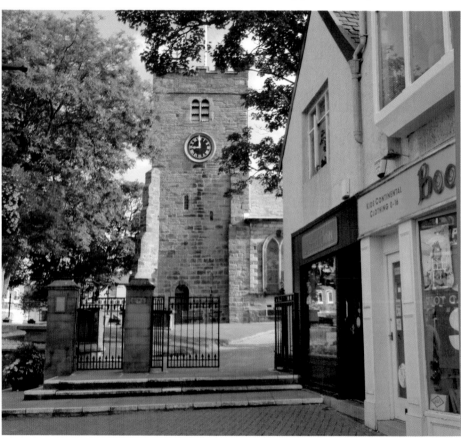

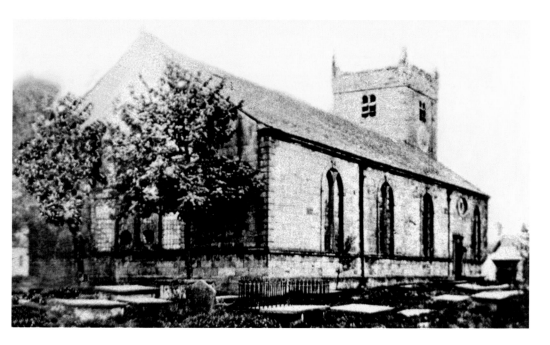

St Chad's Apse

In 1868 an apse was added to the east end of St Chad's, paid for by the vicar Revd Thomas Clark. It was used for the first time at his funeral in March 1869. During the alterations the graves of Edward Sherdley, who died in 1741, and his wife Ellen, had to be moved. Edward's was placed at the foot of the steps leading to the vestry and its design of skull and crossbones – simply used as symbols of death – led to it being called a 'pirate's grave'.

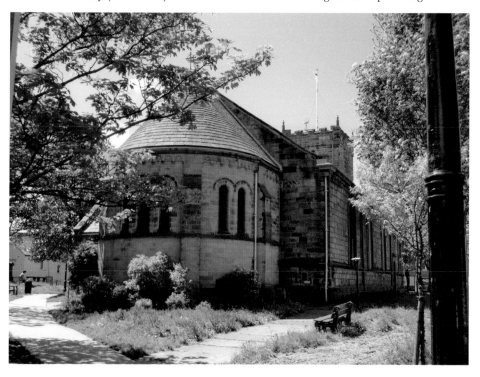

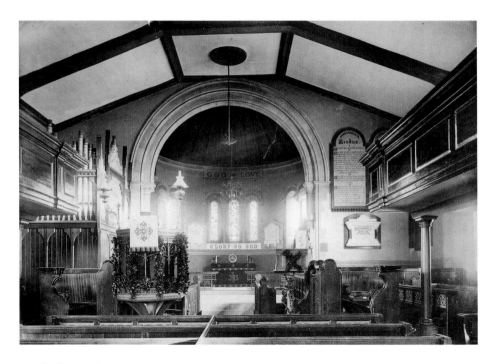

St Chad's Interior

Dating from the 1880s, just after major re-ordering had taken place, the photograph shows the new rows of pews which had replaced the ancient box pews. (The north and south galleries still retain their box pews.) At the same time, the Fleetwood family pew was removed to the back of the church. The new organ was installed in 1912; the centre aisle was added as part of another re-ordering, undertaken in the 1950s.

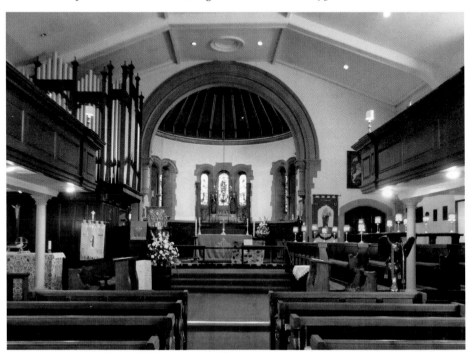

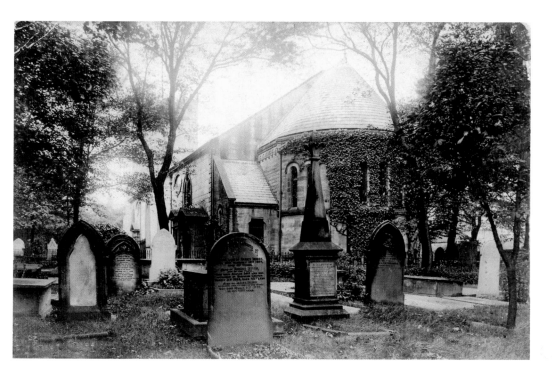

St Chad's Graveyard

Until 1973, when a major re-design took place, St Chad's churchyard was crowded with gravestones and great forest trees planted in the late nineteenth century. As part of the clearance, many of the 'table tombs' were left in place, their inscriptions recording several generations of old Poulton families. Unfortunately, as part of the re-ordering, some gravestones were used for hard core and others were upturned and used to make the paths through the churchyard.

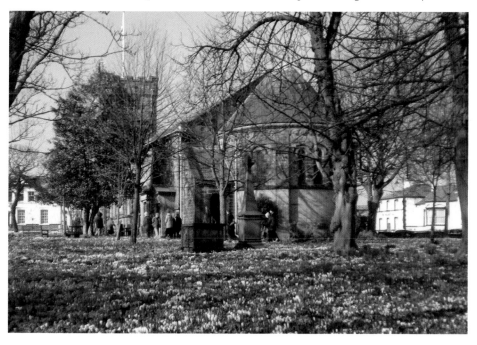

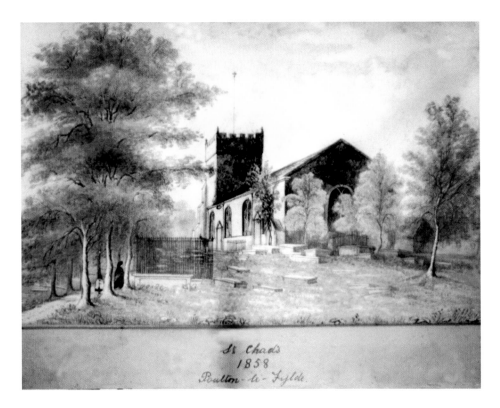

St Chad's
1858
Poulton-le-Fylde.

St Chad's Church Painting

The picture was painted by Miss Lucy Hull, daughter of the Revd Canon John Hull, who was vicar of St Chads from 1837 to 1864. Miss Hull painted the picture in 1858 for the cook at the vicarage as a gift, and the granddaughter of the cook presented the painting to St Chad's in 1964. The trees that Lucy Hull painted over 150 years ago now almost hide the church from view.

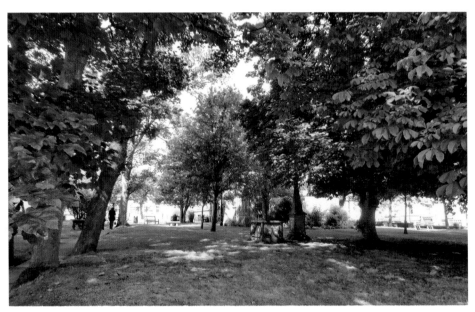

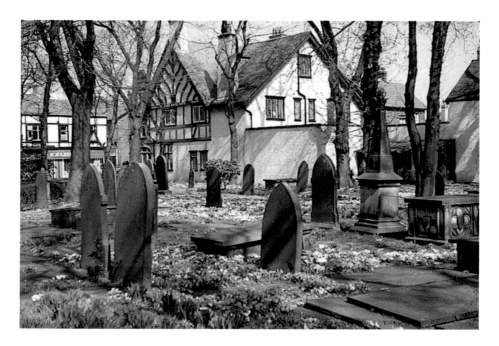

St Chad's Crocus

St Chad's is renowned for the display of crocuses which has appeared in early spring every year for over a century. Until 1910, the churchyard was surrounded by buildings of all descriptions backing onto its walls. The Thatched House by the main gate leading to the Breck is a reminder that all old churches have a public house nearby – in previous centuries parishioners would be in need of refreshment after walking 5 or 6 miles to St Chad's every Sunday.

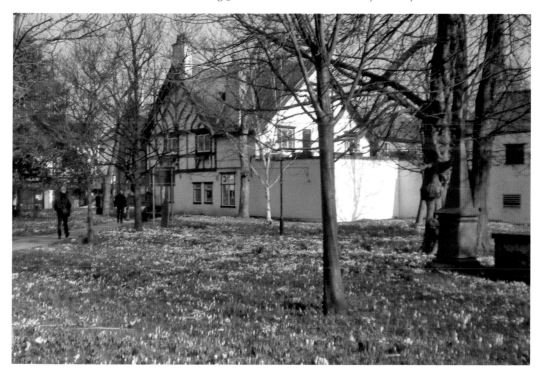

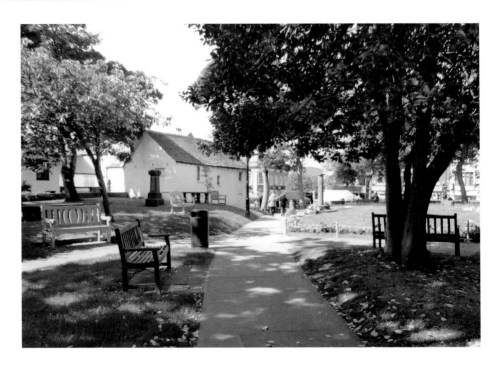

St Chad's Churchyard

There has been a church on this site for at least 1,000 years, and probably longer. In medieval times the church and its large churchyard would have been used for gatherings, fundraising church ales and markets. Today St Chad's churchyard is a main thoroughfare for Poulton people walking from Ball Street or Chapel Street into the Market Place. On a sunny day people enjoy the seats dotted around the grounds, often provided as memorials to loved ones.

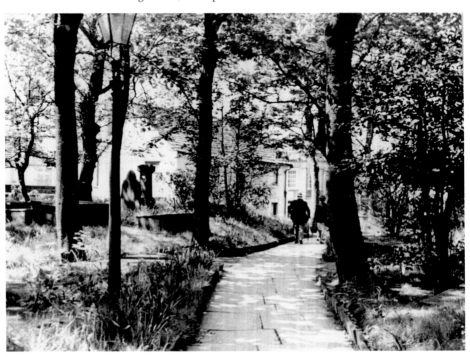

William Lawrenson

William Lawrenson is shown here in his role as verger of St Chad's church. He also served as sidesman, churchwarden and captain of the belfry. He was skilled in wood-carving and cabinet-making and was a fine restorer of antique furniture, with premises on Tithebarn Street. The gates leading into the Market Place and the metal railings that surrounded the churchyard and lined the paths were all removed as part of the war effort in the 1940s.

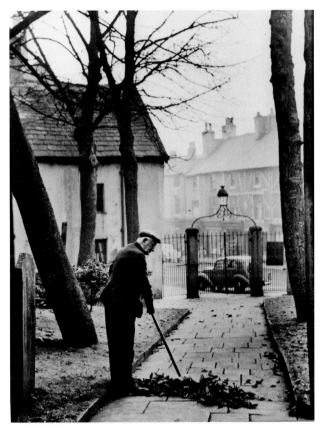

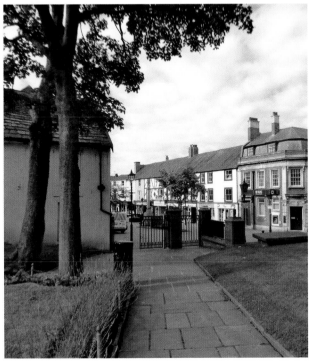

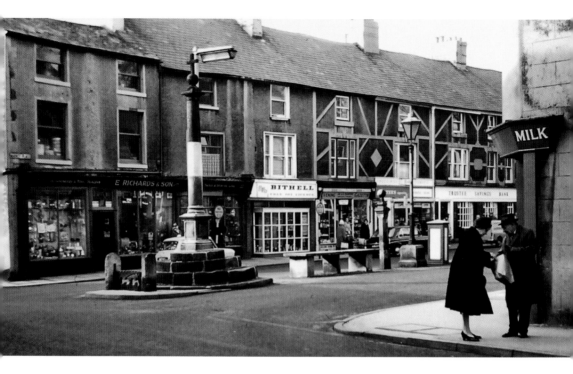

Market Place – West Side

The west side of the Market Place was destroyed by a fire in March 1732. The cause was sparks from lighted tapers carried in a funeral procession setting the thatched roofs alight. It was rebuilt after a nationwide appeal for funds, a process which was common in the eighteenth century. This rebuild resulted in the unified appearance of the row, except for the end property, where the roofline is very different.

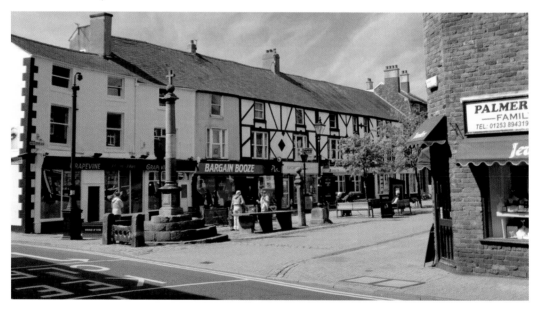

View into Queens Square

To the left of the market cross, in the distance in Queens Square is a large, three-storey house, which had a farmyard behind it with an assortment of outbuildings. These included a two-storey weaving shed, warping and winding house, stables, and piggeries. At one time this was used as the town's workhouse. Only the house remains, now used as offices.

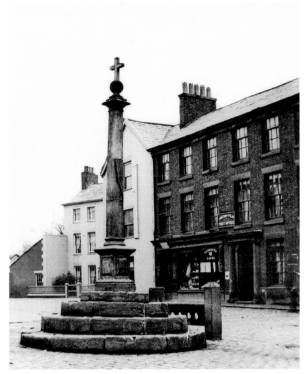

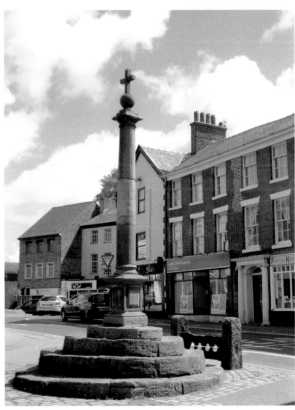

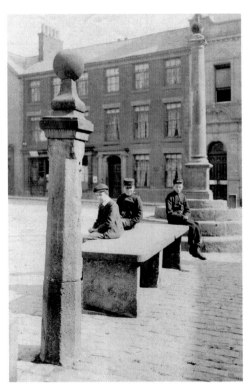

James Baines' House

Two young Post Office Boy Messengers await their next job in the Market Place. The boys were employed by the Post Office in the later Victorian period, primarily to deliver telegrams. In the background is James Baines' house, with its six bays. The modern photograph shows that one bay was lost when the bank was built next to it. Baines' house, with its cruck construction on the first and second floors, was developed into apartments in 2008. When he died in 1717, James Baines left money to fund three free schools for poor boys, all of which continue to flourish.

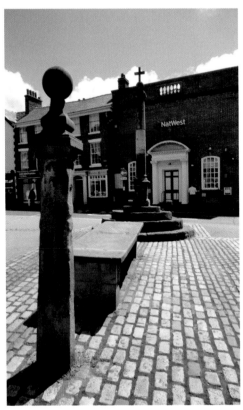

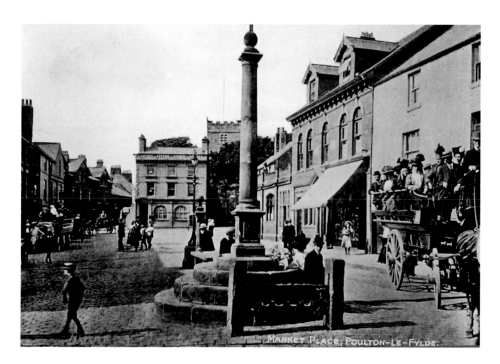

MARKET PLACE, POULTON-LE-FYLDE.

The Market Place

The market cross, whipping post, fish slabs and stocks are remarkable remnants of an earlier time. The building in the background, originally built of brick, was saved from demolition in 1910 and was refaced to match the new wall around the churchyard. It was finally demolished in 1938. The charabanc was a popular mode of transportation for trips. On the right is a horse-drawn charabanc and on the left a motor vehicle is parked outside Mayor's butcher's shop.

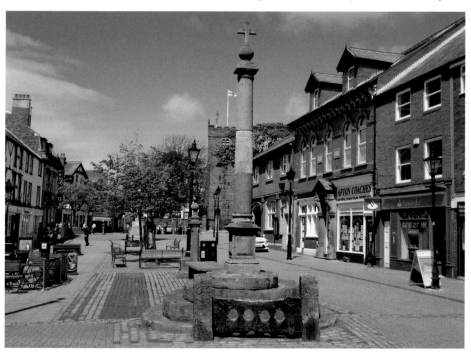

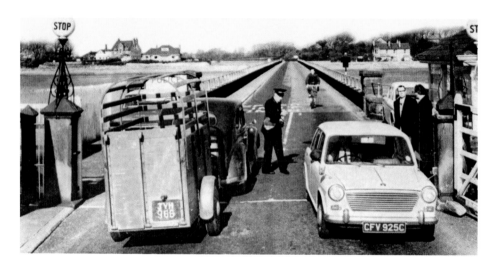

Shard Bridge – from Poulton

The shortest route between Poulton and Lancaster involved crossing the River Wyre, and the old name, Aldwath, used for the ford – and later the ferry – indicates that there could have been a crossing near the present bridge in Anglo-Saxon times. The first bridge was erected in 1864, with the cost each way being seven pence. In 1966 it was 3*d* each way and a penny per passenger. By 1975 cars were charged five pence each way.

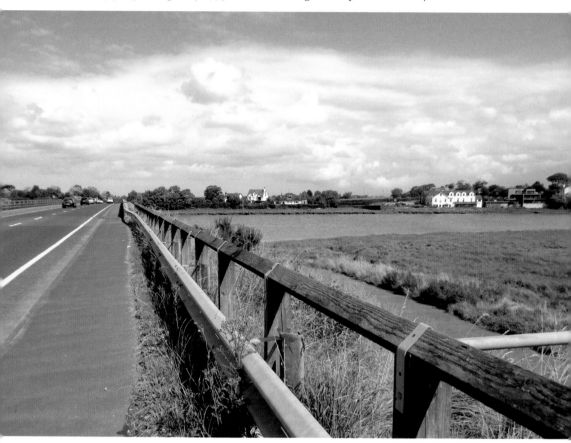

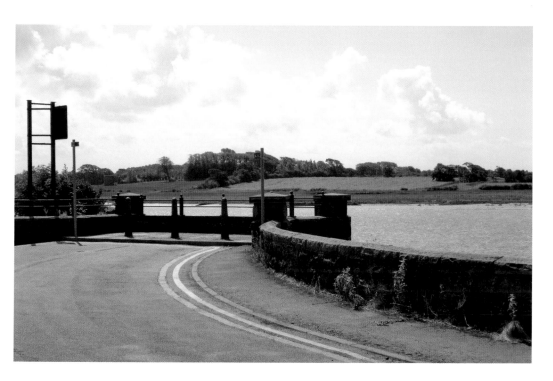

Shard Bridge – to Hambleton

The increase in traffic caused major queues at both ends of the bridge as drivers waited to pay the toll, and in the late 1960s hopes were raised for a new bridge to be built to replace the original one. The present toll-free bridge was eventually started in 1993 and completed the following year. The line of the main road was slightly re-routed at each end of the bridge. On the Hambleton side, the stonework that the cyclist is passing is still there, next to the hotel car park.

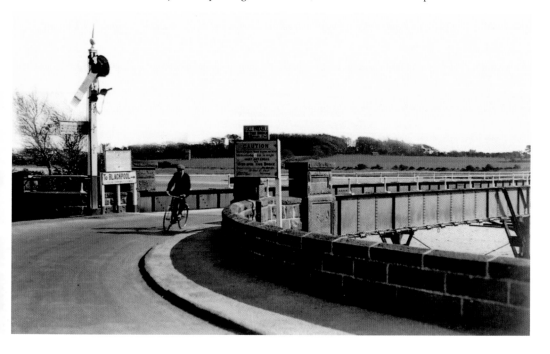

Castle Gardens

Once the Weld Arms, the pub was renamed the Castle Gardens in the late 1880s. The business was developed by succeeding landlords. With a menagerie and entertainments, a rose garden, bowling green, conservatories and refreshments, it attracted visitors from Blackpool and across the Fylde, travelling in horse-drawn charabancs. Some of the land is now occupied by the church of St Martin & St Hilda. Many of the original trees still stand in the car park and in the church grounds.

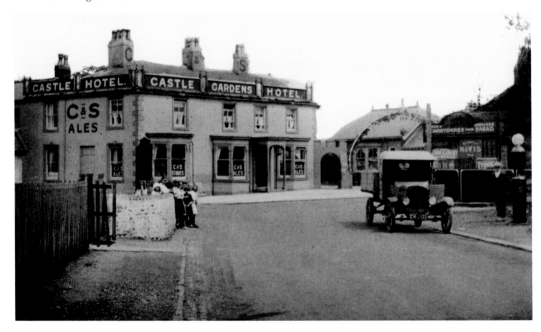

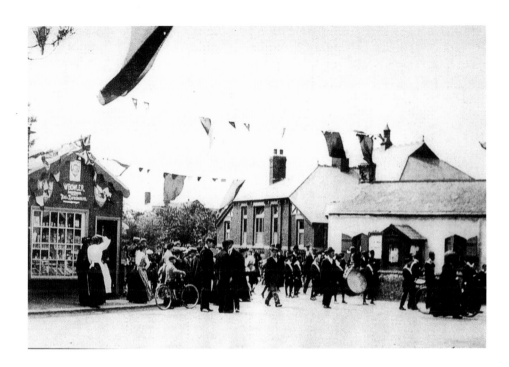

Carleton School

One of the oldest schools in the Fylde, it was founded following the wishes of Elizabeth Wilson in her will of 1680. The small, white building on the right was built of pebbles and mortar with a stone roof and had just two rooms. The larger, red-brick building was erected in 1902. The present school opened in 1967 and was built a little way down Bispham Road. The old buildings remained until 1970, when they were demolished and replaced by several houses.

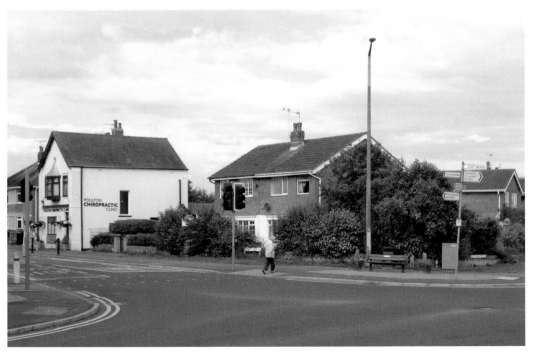

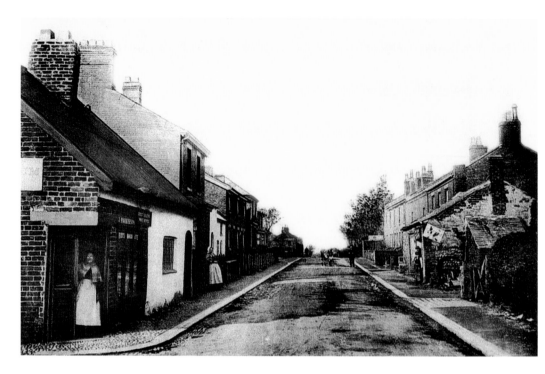

Poulton Road, Carleton

Carleton has always been a farming community and until the early twentieth century there were only three businesses here. On the extreme right can be seen the blacksmith's, and opposite on the left is Parkinson's grocers, a typical Fylde cottage with its shop-front across the corner. This ancient property was demolished in 1973 when the Wyvern Way was built. At the crossroads – originally called Four Lane Ends – stands the Castle Gardens, out of sight behind the trees on the far right.

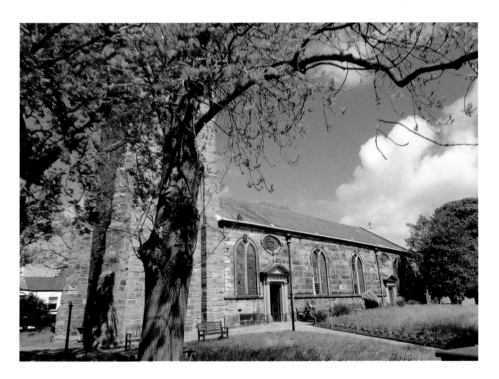

St Chad's from the Market Place

Until a major clearance took place in the 1970s, St Chad's churchyard had become a woodland area, full of large trees. As they cut out the light and damaged the graves several were removed and the many of the gravestones were laid as paths. The whole area is full of snowdrops, crocuses and daffodils in the spring, and throughout the summer the trees give welcome shade.

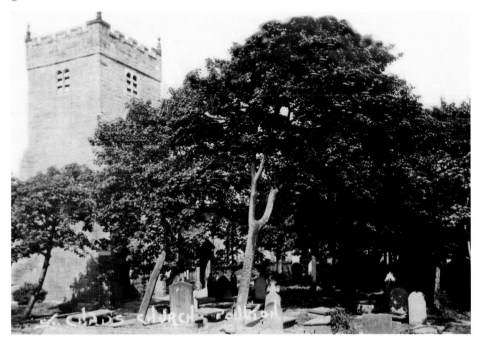

Blackpool Road Carleton

Looking towards the Castle Gardens in the early twentieth century Blackpool Road ran between farm fields. On the left was Leach Farm and further on Greenheys, now marked by Greenheys Avenue. On the right once stood a communal threshing machine. From the 1920s onwards much of the farm land in Carleton was given over to housing, though pockets of woodland still remain.